The Ancestors of Christ Windows

The Ancestors of Christ Windows

AT CANTERBURY CATHEDRAL

~ Jeffrey Weaver and Madeline H. Caviness

The J. Paul Getty Museum • Los Angeles

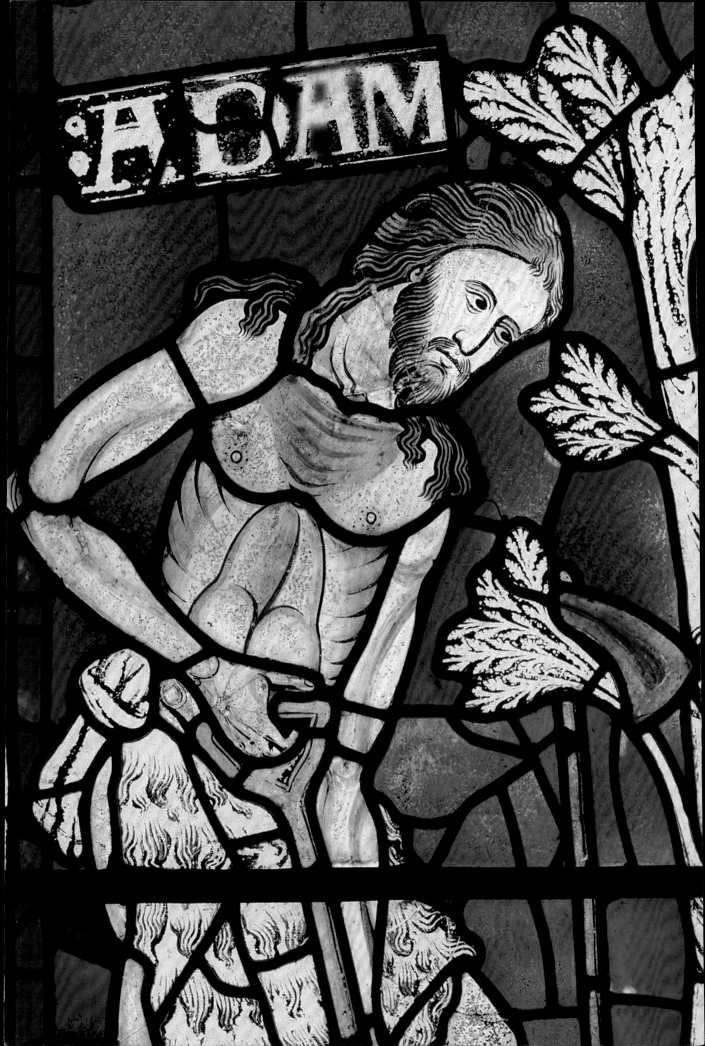

Contents

Note to the Reader
• Quotations from the Bible refer to the New Revised Standard Version (NRSV),
unless otherwise stated.
• Dimensions in captions are given in the order of height by width by depth.
• In "Selected Individual Figures from the Ancestors of Christ Windows" (pages
49–67), citations that appear in short form refer to corresponding full citations
in the bibliography at the back of this book.
• Media and dimensions are included in captions when available.

Foreword

Canterbury Cathedral is renowned for the magnificence of its architecture and the splendor of its stained glass windows, a remarkable number of which have survived from the Middle Ages. Created for the cathedral beginning around 1178, the windows depicting the ancestors of Christ are among the earliest and most important examples of English stained glass. They comprise a series of imposing, life-size figures of seated Old Testament patriarchs, beginning with Adam, representing the genealogy of Jesus.

In 2009 the figures that survived in the Great South Window were removed so that conservation work could be done on the surrounding stone framework. In view of the fact that most of these works would have otherwise remained in storage, concealed from view for an extended period, the Dean and Chapter of Canterbury generously agreed to an unprecedented loan of six ancestor figures to the J. Paul Getty Museum in Los Angeles for the exhibition *Canterbury and St. Albans: Treasures from Church and Cloister*, and thereafter to the Metropolitan Museum of Art in New York for display at the Cloisters. Most of Canterbury's early medieval glass has never before left the cathedral precincts, and these related exhibitions offer a unique opportunity for audiences to experience these rare and imposing panels while also raising awareness of Canterbury's artistic treasures and the challenges it faces in preserving this World Heritage site.

At the Getty, the windows are being shown along with the St. Albans Psalter, a twelfth-century English illuminated manuscript created at St. Albans Abbey that is now in the care of the Dombibliothek Hildesheim in Germany. This splendidly illustrated psalter, arguably the most important surviving English manuscript of its time, includes an exceptional cycle of full-page miniatures showing scenes from the life of Christ as well as more than two hundred illuminated initials. The work is featured in a related Getty publication, *The St. Albans Psalter: Painting and Prayer in Medieval England* (2013). Uniting the ancestors of Christ figures from Canterbury with the images in the St. Albans Psalter provides a unique opportunity to compare masterpieces of twelfth-century English painting ranging from the grand to the intimate: monumental painting on glass created for communal viewership, and miniature painting on parchment made for private readership by the privileged few.

The Getty extends its deepest gratitude to the Very Reverend Robert Willis, Dean of Canterbury; Brigadier John Meardon, Receiver General at Canterbury; Léonie Seliger, Director of Stained Glass at Canterbury; and, at Hildesheim, to Bishop Norbert Trelle and Jochen Bepler, without whose gracious support this extraordinary exhibition would not have been possible. Also critical to the success of the project were the other lending institutions, together with their directors and curators, and a private collector: Thomas Campbell and Peter Barnet at the Metropolitan Museum of Art, New York; Claire Ben Lakhdar-Kreuwen at the Bibliothèque de la codecom de Verdun; William Griswold and William Voelkle at the Morgan Library & Museum, New York; and Sir Paul Ruddock, London.

The Ancestors of Christ windows at Canterbury have not hitherto received the attention they deserve in the general literature on medieval art. For introducing these important works to a wider public, we owe a debt of gratitude to the coauthors of this volume, Jeffrey Weaver, associate curator in the Department of Sculpture and Decorative Arts at the J. Paul Getty Museum, and Madeline H. Caviness, the leading scholar of the stained glass at Canterbury, who catalogued all of the glass in the cathedral for the international Corpus Vitrearum Medii Aevi of Great Britain. In these pages, Weaver traces the original setting, iconographic program, and stylistic development of the Ancestors of Christ, the longest such cycle known, while Caviness examines the Ancestors of Christ theme as presented in the windows at Canterbury, and how it was understood and appreciated by different viewers in the Middle Ages. Together they provide a fresh and enlightening reexamination of one of the masterpieces of English medieval art.

Timothy Potts
Director, The J. Paul Getty Museum

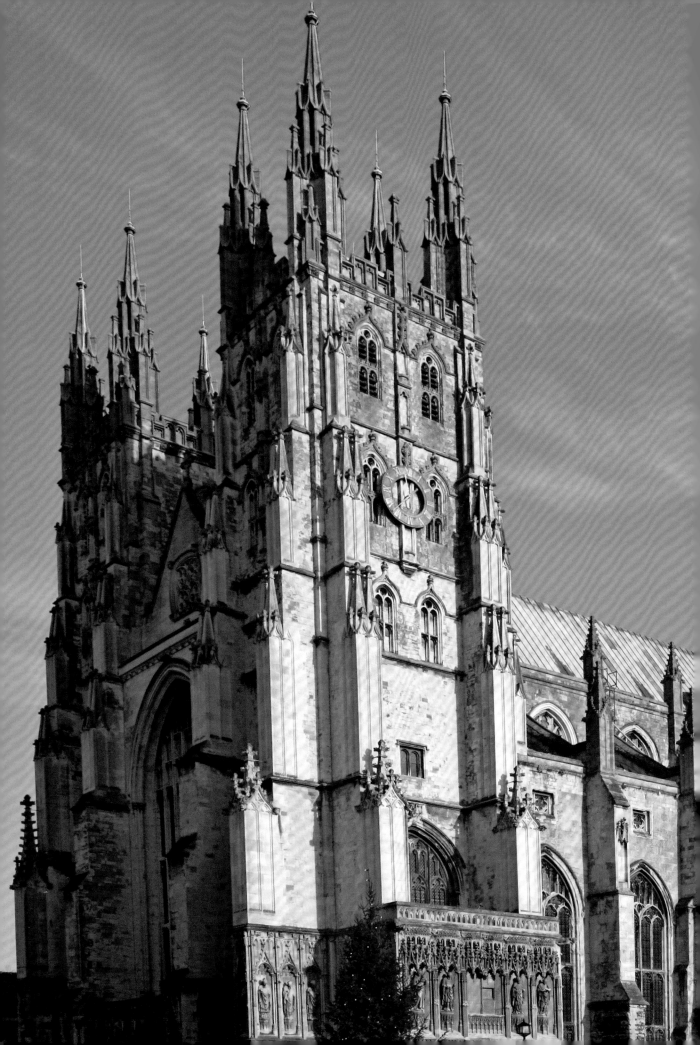

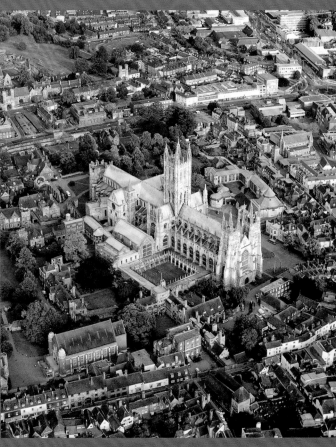

Fig. 1 | Two views of Canterbury Cathedral: *left*, from the southwest; *above*, in an aerial photo from the northwest

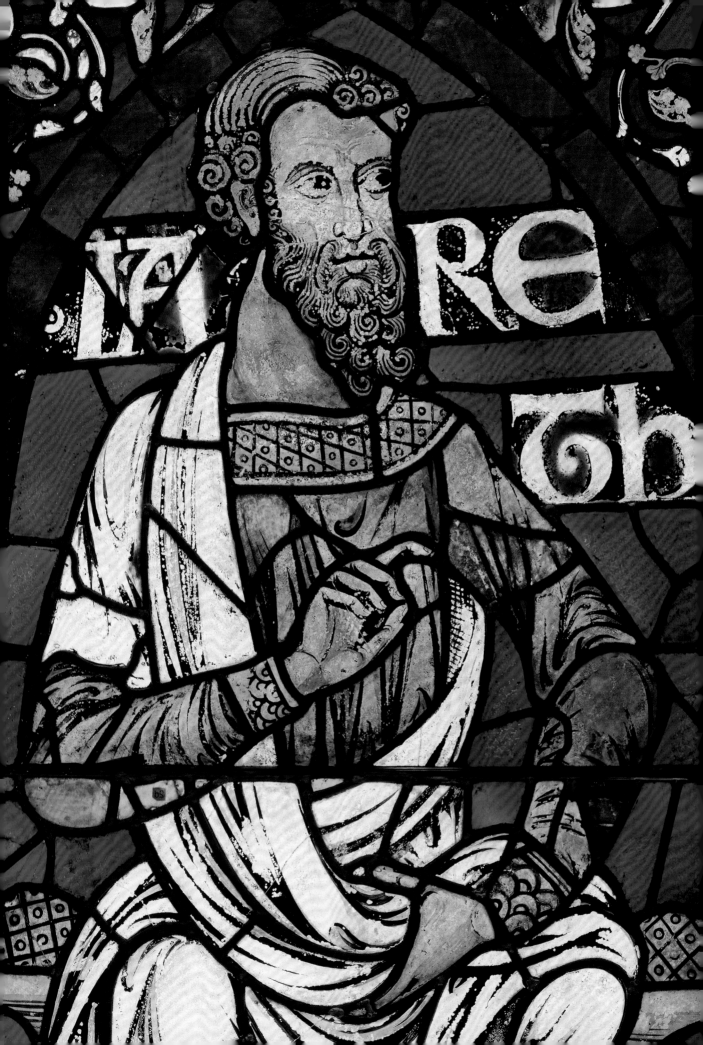

The Ancestors of Christ Windows: Context, Program, Development

Jeffrey Weaver

The surviving twelfth-century windows from Canterbury Cathedral (fig. 1) representing the ancestors of Christ are among the oldest panels of stained glass in England and significant examples of what was at the time a relatively new art—monumental stained glass. Depicting the genealogy of Christ as it is listed primarily in the Gospel of Luke, the Ancestors of Christ series was originally housed in the clerestory ringing the choir, eastern transepts, and sanctuary of the cathedral. Made of colored glass, with the details of the faces and costumes painted on the surface, the windows show imposing, life-size seated male figures (fig. 2) that are considered to be among the most famous works of English medieval painting. They were created soon after a fire damaged the choir in 1174 when the cathedral was being redesigned to include a shrine for the recently canonized Thomas Becket (born ca. 1118), who had been murdered there in 1170.

Canterbury has been the seat of the archbishop of Canterbury, primate of all England, since 597 CE; and from the tenth century until the Reformation in the sixteenth century it was also the richest and most prominent monastic cathedral in Britain. During that time the building served as both a cathedral and a priory church housing a community of Benedictine monks. Although the archbishop was formally the abbot, the monastery operated under the leadership of the prior, the superior officer of the monks; and the cathedral church itself together with the cloister and associated buildings was officially a priory. The heart of the cathedral is the choir, where the monks met for a daily sequence of prayer services known as the Divine Office. The services were based on the reading through of the book of Psalms in the Old Testament—the entire psalter of 150 psalms being read through in sequence during the course of a week. The office took place at specific intervals during the day and night so that prayer was continually offered in a recurring rhythm of chant and recitation in the magnificent setting provided by the architecture and windows.

One of the monks, Gervase, witnessed the fire of 1174 and left an account of the rebuilding of the choir.[1] His important work documents how this part of the

Fig. 2 | *Jared*, from the Ancestors of Christ Windows (detail, fig. 28)

11

church was reconstructed over the following ten years, the period during which, it is assumed, many of the windows for the Ancestors of Christ series were installed. Remarkably, the structure of the choir has remained largely untouched since its completion in 1184.[2] Six hundred years later, in the mid-eighteenth century, William Gostling, a "native of the place, and minor canon of the Cathedral," wrote *A Walk in and About the City of Canterbury with Many Observations Not to Be Found in Any Description Hitherto Published.*[3] The second edition was printed in 1777, soon after the author's death that year. Gostling's description of the ancestor figures in the clerestory windows is critical for our understanding of their original placement before most of the surviving figures were repositioned at the end of the eighteenth century. In 1977 Madeline Caviness published an extensive study of the early stained glass at Canterbury;[4] it was followed, in 1981, by her catalogue of all the Canterbury glass for the Corpus Vitrearum.[5] Together the two works remain the definitive analysis and interpretation of the windows.

The windows at Canterbury should be considered in the history of English medieval painting. One of the most important English illuminated manuscripts of the twelfth century is the St. Albans Psalter, created at St. Albans Abbey north of London. This psalter contains the most extensive series of Life of Christ images of its time. These full-page miniatures, like the one shown here (fig. 3), were painted by an artist known as the Alexis Master, whose fully modeled figures, rich colors, and elaborately patterned borders mark the introduction of Romanesque painting to England. His style had a powerful influence on English painting, echoes of which seem evident in the monumental early compositions in the Ancestors of Christ figures at Canterbury.

The St. Albans Psalter notably includes text from Pope Gregory the Great's famous letter encouraging the use of images to enhance devotion and assist the illiterate to see "what they ought to follow."[6] His letter was written about 600 CE, the same time Canterbury was founded, and it served as an important justification for the use of representational images in the art of the West. During the twelfth century that sentiment had fresh relevance in light of the teachings of Saint Anselm (1033–1109), archbishop of Canterbury from 1093, whose influential writings encouraged meditation engaging the senses. It was thought that pictures could prompt the beholder to become more emotionally involved in prayer.[7] Monumental stained glass windows, a then-new phenomenon, were, and still are, an art form accessible to a broad public of all educational levels and every position in society.[8] These remarkably large and luminous images worked in conjunction with the architectural setting and liturgical ceremonies, with their related music and incense, to create in the worshipper an overwhelming sense of introspection, holiness, and awe.[9]

Seeing the windows at Canterbury Cathedral, the contemporary beholder experiences them in much the same manner as did the medieval viewer; most, unfamiliar with the specific meanings of the images, would nevertheless feel a

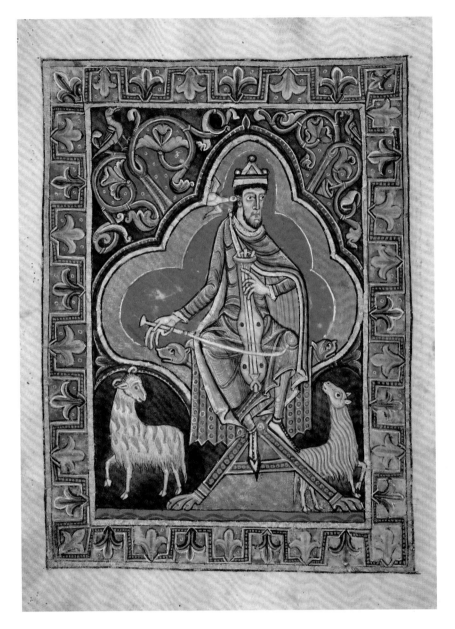

Fig. 3 | *David as a Musician*, from the St. Albans Psalter, St. Albans Abbey, England. Attributed to the Alexis Master, ca. 1130. Tempera and gold leaf on parchment, 27.5 × 18.5 cm (10⅞ × 7¼ in.). Dombibliothek Hildesheim, HS St. God. 1, p. 56

In the St. Albans Psalter the text of the psalms is preceded by a sequence of full-page miniatures illustrating scenes from the Life of Christ. The sequence ends with this image of King David, traditionally considered the author of the book of Psalms. Here the dove of the Holy Spirit whispers into David's ear as he plays a stringed musical instrument as accompaniment for singing the psalms.

sense of weight and history or simply be struck with pleasure and admiration. Writing in the mid-eighteenth century, Gostling references such basic reactions at the beginning of his chapter 31, "Of the Inside of the Church":

> We now enter the body of the church [Canterbury Cathedral] . . . , in company I will suppose with some of our colonists just arrived from America, in their first visit to England; persons blessed by providence with a capacity to be struck with the sight of what is grand and beautiful, without troubling themselves to consider, whether the grandeur and beauty with which they are charmed be owing to the rules of Grecian or Gothic architecture. At the first entrance with such [visitors] into this noble structure, how have I enjoyed their astonishment![10]

Fig. 4 | Plan of Canterbury Cathedral

1. Great West Window

2. The Martyrdom—site of Thomas Becket's murder

3. High altar

4. Position of temporary wooden wall put up in 1180

5. Saint Augustine's Chair

6. Saint Andrew's Chapel

7. Miracle Windows

8. Site of Thomas Becket's shrine from 1220 to 1538

9. Saint Anselm's Chapel

10. Great South Window

The Original Context

Like many medieval cathedrals, Canterbury as it exists today (see plan, fig. 4) is the product of a number of different building campaigns. What visitors experience now is the result of two major architectural programs. The section to the east of the nave housing the choir, eastern transepts, presbytery, and Trinity Chapel was built during the late twelfth century and is one of the most important works of early Gothic architecture in England. The section to the west of the choir housing the western transepts, nave, and West Door of the cathedral was constructed

Fig. 5 | The Choir, Canterbury
Cathedral

during the late fourteenth century and is one of the finest surviving examples of
English High Gothic architecture. The earlier section at the eastern end, the most
sacred part of the cathedral, is illuminated by tall windows at the top section of
the wall, known as the clerestory, which were designed to house a series of stained
glass figures representing the ancestors of Christ.

The central area of the eastern part of the church is referred to generally as the
choir (fig. 5). It is divided into three sections: the choir proper, which contained the
stalls for the monks; the presbytery, which extends east from the choir to include

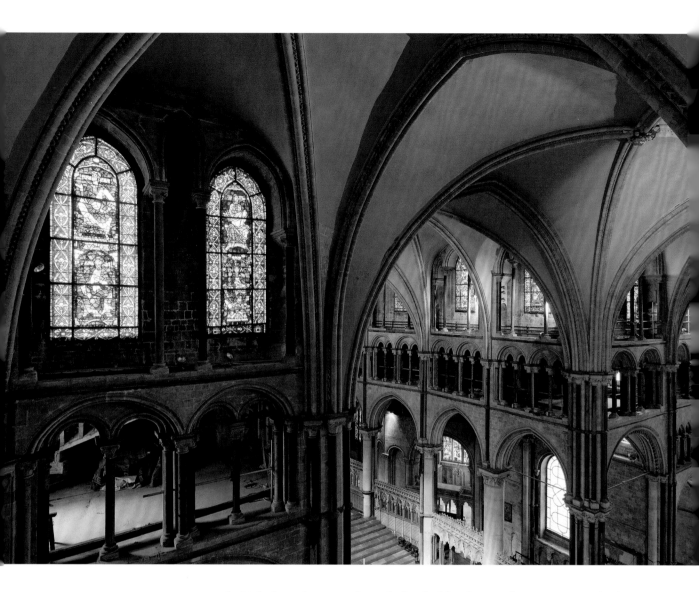

the high altar a few steps above the level of the choir; and Saint Augustine's Chair, which is raised on a level higher still.[11] At that highest level, east of the chair, the space narrows and ends in an apse known as the Trinity Chapel, which was built to house the shrine of Saint Thomas Becket. The shrine itself was destroyed during the Reformation in the sixteenth century. The choir and presbytery are flanked by a wide aisle that continues as an ambulatory around the Trinity Chapel. The arrangement allowed pilgrims to circumnavigate the choir to observe the shrine area at the end while leaving the central section free for the monks' worship.

These spaces—the choir, eastern transepts, presbytery, and Trinity Chapel— are unified by the vaulting of the church and forty-seven lancet clerestory windows. Most of the windows originally contained figures from the Ancestors of Christ series, each lancet housing two figures, one above the other, surrounded by a wide decorative border (fig. 6). Placed at such a height in the clerestory, they could be seen by the monks as well as visiting pilgrims.

Ancestry and succession are important subjects in this building that marks the foothold of the Christian Church in England. During the Middle Ages the archbishop of Canterbury was the pope's representative, being the principal bishop, or primate, of the realm. The pope is considered the successor of the apostle Peter, the successor of Christ, who is descended from God. The archbishop's chair, referred to as Saint Augustine's Chair (named for the first archbishop of Canterbury), was therefore associated with the *cathedra* (chair) of the pope at Saint Peter's Basilica in Rome. Since the break with Rome during the Reformation, Canterbury has remained the mother church of England and seat of the Anglican Communion. Chairs are important symbols of power, and the themes of history and continuity, ancestry and succession, legitimacy and authority would have been echoed in the images of the monumental seated figures of the ancestors of Christ in the clerestory windows.

The eastern part of the building was constructed over the decade following the fire of 1174.[12] It was begun that year by the French master mason William of Sens, who worked until after he was injured in a fall from the scaffolding in September 1178. He retired and returned to France early in 1179. The succeeding mason, known as William the Englishman, continued the project until it was finished in 1184. Indeed, the choir and much of the presbytery were completed to such a degree that the monks were able to return to the choir to celebrate Easter in 1180. One of their members, Gervase, described how they had been seized with a violent longing to return to the choir and were able to process back into the new space on Easter Eve, April 19, 1180, to conduct services there the following day.[13] In the daylight of Easter Sunday, the monks would have seen that many of the windows from the Ancestors of Christ series were installed in the clerestory. It is presumed that the section from the west end of the choir to the initial part of the presbytery was glazed by that point, since the glass was likely put in as soon as the vaults were in position.[14] Gervase notes that a temporary wooden wall with three glass windows in it was erected just beyond the high altar to keep out the weather while the eastern end of the presbytery and the Trinity Chapel were still being built.[15]

The new choir by William of Sens and William the Englishman was constructed upon the remains of an earlier one that had been completed in the first quarter of the twelfth century. The previous choir had been built at the behest of Saint Anselm, archbishop of Canterbury from 1093 to 1109, during the time of the priors Ernulf (ca. 1096–1107) and Conrad (1108/9–1126), and it was consecrated in 1130.[16] Anselm's Choir, also known as Conrad's Choir and the Glorious Choir, was particularly celebrated for the splendor of its decoration. According to one contemporary writer, "Nothing like it could be seen in England, whether for the brilliancy of its glass windows, the beauty of its marbled pavements or the many colored pictures."[17] The aisle windows of Anselm's Choir were exceptionally large and apparently filled with expensive stained glass.[18] If so, they would have been among the earliest monumental stained glass windows in Europe, possibly

Fig. 6 | Two Clerestory Windows, northeast transept, Canterbury Cathedral

Fig. 7 | *The Martyrdom of Thomas Becket at Canterbury Cathedral*, a late-twelfth-century leaf inserted into a thirteenth-century English psalter. Ink, pigments, and gold on vellum, 31.3 × 21.8 cm (12¼ × 8½ in.). London, The British Library, Harley Ms. 5102, fol. 32

This manuscript illumination shows the four knights who participated in the assassination of Becket—Reginald FitzUrse, Hugh de Morville, William de Tracy, and Richard Le Breton—in the middle of the assault. One, possibly de Tracy, strikes the arm of the crossbearer, Edward Grim, who was wounded and later wrote an eyewitness account of the attack. FitzUrse, recognized by the bear on his shield (*ours* is French for "bear"), strikes the top of Becket's head, knocking off his cap, which falls to the floor.

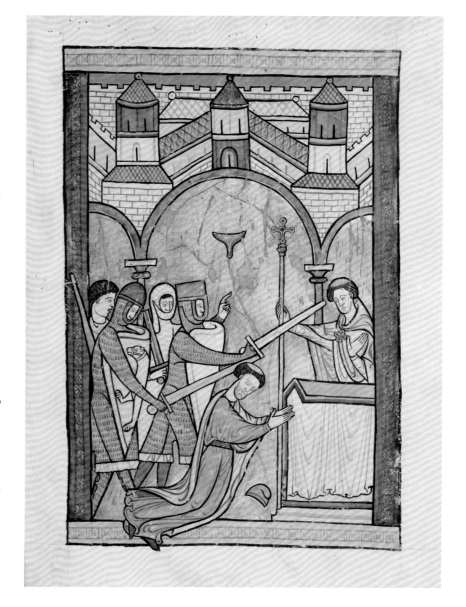

predating the famous windows at the Abbey of Saint-Denis, north of Paris, generally regarded as the first of the type. Consequently, the prominent use of stained glass had an impressive antecedent at Canterbury.

The legacy of Anselm and his choir were significant influences on the archbishops, monks, and artists involved in the production of the new choir. Anselm's life and teachings had been important to Thomas Becket, who is said to have modeled his conduct as archbishop on Anselm, an extraordinary scholar and defender of the Church who, like Becket, also came into conflict with the monarchy.[19] Becket had promoted Anselm's canonization, and it has been suggested that the essentials of the decorative scheme of Anselm's Choir were reinstated for the reconstruction of the new choir soon after Becket's death, demonstrating a desire for continuity with the earlier program. Indeed, the aisle walls of Anselm's Choir were restored

Fig. 8 | *The Cure of Robert of Cricklade*, from the Becket Miracle Windows in the north ambulatory of the Trinity Chapel, Canterbury Cathedral. Attributed to the Petronella Master, early thirteenth century. Colored glass and vitreous paint, 76 × 77 cm (29⅞ × 30¼ in.), n. IV, 28

The scene in this panel shows a lame pilgrim, Robert of Cricklade from Oxford, being assisted as he kneels to pray at the tomb of Thomas Becket. The image represents the initial tomb in the cathedral crypt, the one at which many miracles are reported to have occurred. Another panel shows Robert, cured, returning to place his crutch on the tomb in gratitude for his healing. The head of the figure at the right and the bearded head of Robert were replaced in the twentieth century.

and the large window openings filled with new glass. It is possible that a few glass panels had survived from Anselm's Choir and were retained to be installed as part of the Ancestors of Christ series in the clerestory; this would indicate that the ancestors theme in the new choir took over the earlier twelfth-century scheme.[20]

An important catalyst for the development of the new choir was the tremendous effect that the martyrdom of Thomas Becket in the cathedral on December 29, 1170, had on the community (fig. 7). The murdered archbishop was first buried in the crypt below the eastern end of the church. Miracles began to be recorded soon after pilgrims were permitted to visit the tomb in 1171 (fig. 8). The relocation of Becket's relics from their initial position to a more prominent setting in the upper church had been envisioned in the papal bull of canonization in 1173.[21] Becket's was one of the swiftest canonizations in the history of the medieval

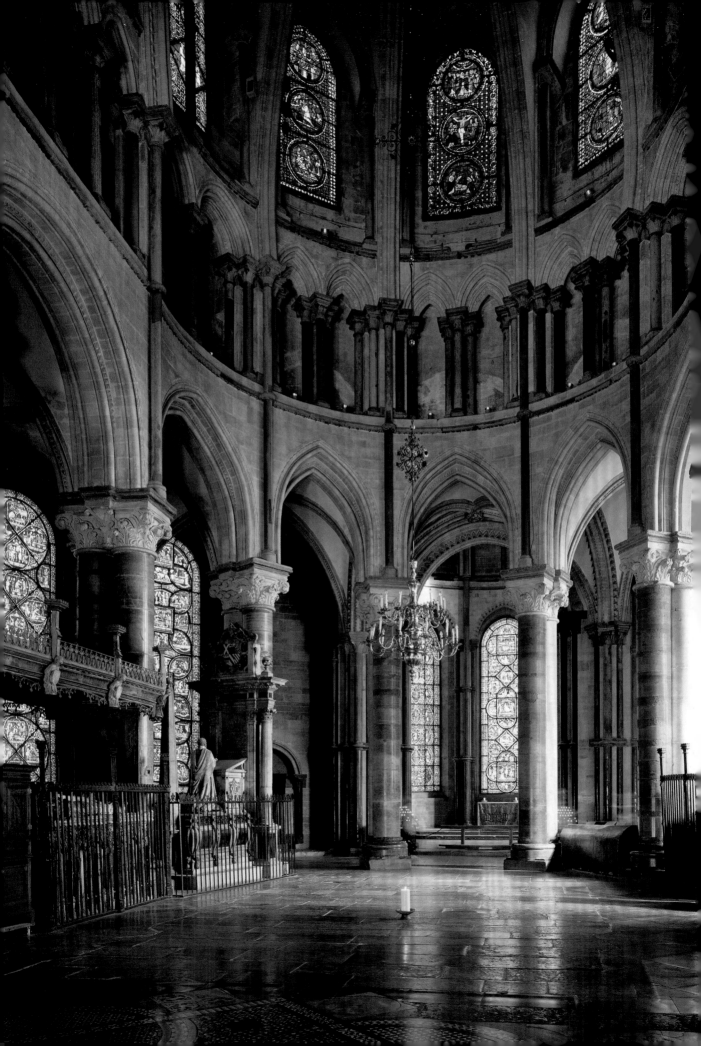

Fig. 9 | The Trinity Chapel, Canterbury Cathedral

A candle marks the spot where Saint Thomas Becket's shrine once stood.

Fig. 10 | *Pilgrim's Badge of the Shrine of Saint Thomas Becket at Canterbury*, made in Canterbury, ca. 1350–1400. Cast tin-lead alloy, 7.9 × 6.4 × 0.3 cm (3⅛ × 2½ × ⅛ in.). New York, The Metropolitan Museum of Art, Gift of Dr. and Mrs. W. Conte, 2001, 2001.310

This pressed-metal badge is one of the best surviving images of the Becket shrine as it existed from 1220 until it was destroyed in 1538. It shows the effigy of the saint supported on an open-work structure resting below the gabled, gold-and-jewel-encrusted shrine that housed the saint's remains.

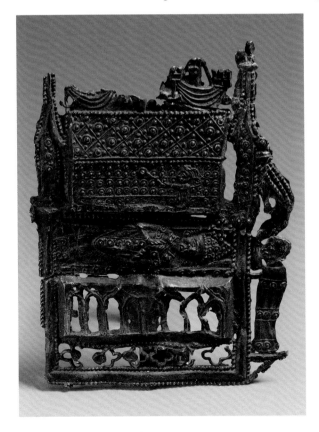

Church, and his cult spread quickly; he was revered not just as a national hero but also, and primarily, as a symbol of ecclesiastical resistance to secular authority.[22] Pilgrims from throughout Europe flocked to his tomb in the crypt on individual quests for healing and the remission of sin. People from every section of society—peasants, laborers, merchants, nobles, and royalty—came. Among the many high-profile visits was the one in 1179 by Louis VII, the first French king ever to see England, in the company of King Henry II and a large delegation of nobility.[23] This flood of pilgrims brought even greater fame and prestige to Canterbury. The fire that damaged the church in 1174, the year following Becket's canonization, presented an opportunity to redesign the eastern end of the choir to house a shrine for the saint's relics. That goal was spectacularly realized by William the Englishman in his completion of the Trinity Chapel (fig. 9).

While the structure of the Trinity Chapel was complete by 1184, the full cycle of clerestory windows and the ambulatory windows showing the miracles associated with the Becket cult were not finished until the early thirteenth century. And Becket's relics were not moved from the crypt to a golden shrine at the center of the chapel until July 7, 1220 (fig. 10). Although the shrine was destroyed in 1538 during the reign of Henry VIII, and time has bleached the chapel of much of its color, the dramatic space is still lit with an extraordinary amount of surviving stained glass.[24] Being surrounded by such a quantity of brilliantly colored glass evokes the sense of being within a vast enameled reliquary.[25] That sensation would have been intended by the original builders and experienced by the pilgrims who traveled from many countries to visit one of the richest and most venerated shrines in Europe.

In addition to the impressive architecture at the cathedral, many other works of the highest quality were produced in Canterbury, a town that from the time of the Norman Conquest in 1066 had become an important center of learning and the arts. Its geographic position in the southeast corner of England, the closest part of the island to the Continent, and the new Norman ruling class meant that Canterbury throughout the twelfth century participated in the larger cultural sphere of Normandy, northeastern France, and Flanders. Many commercial and artistic enterprises linked these regions, and the artists at Canterbury were responsive to them.[26]

The artists who painted the figures in the Ancestors of Christ series of clerestory windows could thus draw on a broad artistic tradition in

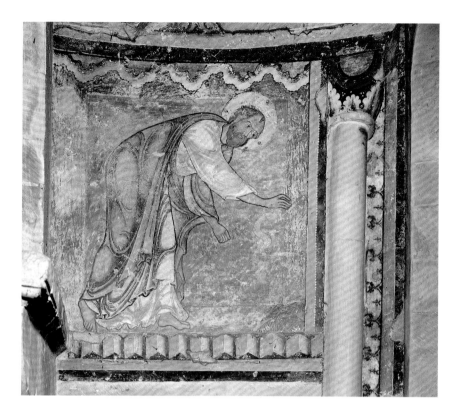

Fig. 11 | *Saint Paul and the Viper*, wall painting in Saint Anselm's Chapel, Canterbury Cathedral, third quarter of the twelfth century

The last two chapters in the Acts of the Apostles tell the story of the apostle Paul's journey as a prisoner when he was transferred from Jerusalem to Rome. After the prisoners' ship was wrecked in a storm, the men sought refuge on the island of Malta. There Paul was bitten by a viper but lived to cure diseases among the local inhabitants and then continued the voyage to Rome.

Canterbury, not just the model of Anselm's Glorious Choir but also the rich tradition of illuminated manuscripts—many important examples of which were produced and housed in Canterbury during the twelfth century.[27] The impact of the Alexis Master (see fig. 3) on the development of painting in England at the time has been noted. Many painters absorbed elements from this artist, such as his representation of strongly modeled figures that dominate the picture frame and his richly colored backgrounds consisting of one block of color set inside another. The influence of his style can be seen in the wall painting at Canterbury showing Saint Paul on the island of Malta shaking a viper from his hand (fig. 11). The scene was painted on the wall of the chapel formerly dedicated to Saints Peter and Paul, now known as Saint Anselm's Chapel, and may date from around the time that Archbishop Thomas Becket had Anselm's remains moved to the chapel and began the process that would lead to Anselm's canonization.[28]

Something of the nobility and weight in the depiction of Saint Paul can be seen in the figure of Adam in the first window of the Ancestors of Christ series (fig. 12, and detail, p. 4). Affinities include the wavelike rendering of a golden cloud along the sky at the top edge of the image. *Saint Paul and the Viper* is the finest surviving twelfth-century mural in England and indicative of the largely lost art of monumental wall painting in medieval England. It and the figures from the Ancestors of Christ series attest to the strong tradition of painting at Canterbury in the twelfth century, which was manifest not only in manuscript illumination but also in wall painting and stained glass.

Fig. 12 | *Adam*, from the Ancestors of Christ Windows, Canterbury Cathedral. Attributed to the Methuselah Master, 1178–80. Colored glass and vitreous paint, 142 × 69.4 cm (56 × 27¼ in.), W. 2d

Adam toils at cultivating the earth by digging with a spade, the labor representing a consequence of original sin and the expulsion from the Garden of Eden. He wears a sheepskin or goatskin tied around the waist. It was believed that the skin from the dead animal signified the mortality that Adam's sin brought to humanity. This figure is exceptionally well preserved.

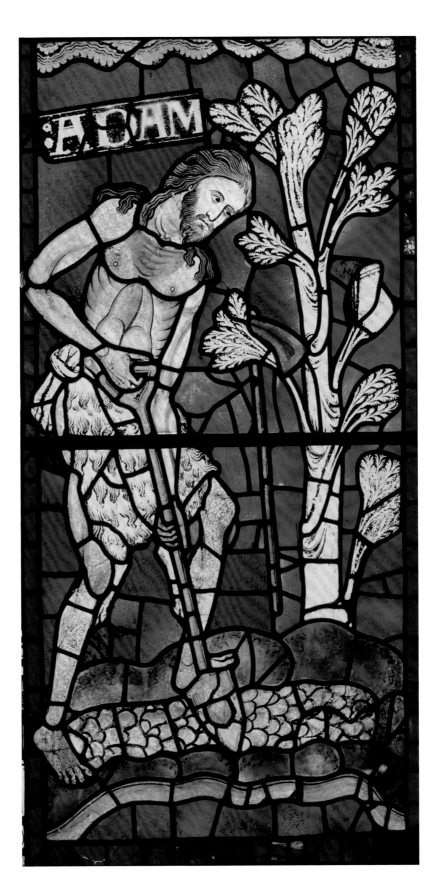

The Iconographic Program

In the mid-eighteenth century, when William Gostling published a description of the forty-seven windows in the clerestory of the early Gothic part of the cathedral, about half (22) of the windows retained their original glazing; he described the remainder as having plain (21) or mixed (4) glass. Gostling wrote, "The subject of them appears to have been the genealogy of our blessed Savior."[29] The individual figures are identified by the name bands behind the heads. Gostling noted that they formed a series that probably began with an image of God in the upper half of the first window at the northwest end of the choir. The surviving figure of Adam was in the lower half of the same window.[30] The series ran eastward along the north side of the clerestory in the choir, continuing around the northeast transept, the north side of the presbytery, and the east end of the Trinity Chapel, then extending west along the same sections of the south side of the church, ending in the southwest corner of the choir.

Although recognized as a series of figures representing the genealogy, or ancestors, of Christ, the sequence of windows had significant gaps, particularly along the south side of the church, where most of the original glass was gone. Six figures remained, however, in the southeast transept, indicating that the series was meant to continue along the whole course of the clerestory. In the 1970s, when Madeline Caviness catalogued all the stained glass in the cathedral, she developed a proposal for the reconstruction of the original clerestory program (fig. 13), based on a systematic evaluation of the physical evidence.[31] The plan begins with the Creator and Adam on the northwest end of the choir, where Gostling described them to be, and suggests that the series terminated with the Virgin and Christ on the southwest end. The sequence was interrupted at the cardinal points—the oculus windows in the north and south walls of the east transept, and the three windows in the apse at the east end of the Trinity Chapel. The program would have included eighty-six individual ancestor figures and thus formed the longest Ancestors of Christ series known in art. Forty-three individual figures survive today, though most were moved to other parts of the church in the late eighteenth century.[32]

The Ancestors of Christ series at Canterbury is based primarily on the genealogy of seventy-seven names contained in the Gospel of Luke (3:23–38),[33] with an additional eight names from the Gospel of Matthew (1:1–17), which has a shorter list of forty-one names.[34] The two genealogies differ in that Luke begins with Jesus and traces the genealogy back to Adam; Matthew begins with Abraham and traces the genealogy forward to Jesus. As described by Gostling the Canterbury figures began with Adam and followed the list of ancestors in Luke to Nathan, one of David's sons. Eight figures from Matthew were included at that point, then the sequence continued with names from Luke. It seems possible that when the new choir was designed after the fire in 1174, the plan was to adhere to Luke's genealogy for the clerestory since it, being the longer list, provided enough names to fill the circuit of windows if the reconstruction conformed to the footprint of Anselm's

Last Judgment I (G. 25)

narrative?	N. II (G. 24)	S. II (G. 26)	*narrative?*
Achim? Joseph?	N. III (G. 23)	S. III (G. 27)	*Mattatha Menan*
Jechonias Salathiel	N. IV (G. 22)	S. IV (G. 28)	*Melea Eliakim*
Ezekias Josias	N. V (G. 21)	S. V (G. 29)	*Jonan Joseph*
Roboam Abia	N. VI (G. 20)	S. VI (G. 30)	*Juda Simeon*
David Nathan	N. VII (G. 19)	S. VII (G. 31)	*Levi Matthat*
Obed Jesse	N. VIII (G. 18)	S. VIII (G. 32)	*Jorim Eliezer*
Salmon Booz	N. IX (G. 17)	S. IX (G. 33)	Jose Er
Aminadab Naasson	N. X (G. 16)	S. X (G. 34)	*Elmodam* Cosam
Esrom Aram	N. XI (G. 15)	S. XI (G. 35)	*Addi Melchi*
Juda Phares	N. XII (G. 14)	S. XII (G. 36)	Neri *Salathiel*

Phalec Ragau N. XVI (G. 10) *Saruch Nachor* N. XV (G. 11) Thara Abraham N. XIV (G. 12) *Jacob* Isaac N. XIII (G. 13)

Zorobabel Rhesa S. XIII (G. 37) Joanna Juda S. XIV (G. 38) Joseph Semei S. XV (G. 39) *Mattathias Maath* S. XVI (G. 40)

Moses and Synagogue
Etc.
N. XVII (oculus)

Christ and Ecclesia?
Etc.
S. XVII (oculus)

Heber *Sala* N. XVIII (G. 8) *Cainan Arphaxad* N. XIX (G. 7) Shem Noah N. XX (G. 6)

grisaille? S. XX (G. 44) *Naum* Amos S. XIX (G. 43) *Nagge Esli* S. XVIII (G. 42)

Methuselah Lamech	N. XXI (G. 5)	S. XXI (G. 45)	*Mattathias* Joseph
Jared Enoch	N. XXII (G. 4)	S. XXII (G. 46)	*Janna Melchi*
Cainan Maleleel	N. XXIII (G. 3)	S. XXIII (G. 47)	*Levi Matthet*
Seth Enos	N. XXIV (G. 2)	S. XXIV (G. 48)	*Heli* Joseph
Creator Adam	N. XXV (G. 1)	S. XXV (G. 49)	*Virgin* Christ

Fig. 13 | Diagram showing the original locations for the Ancestors of Christ figures in the clerestory of the choir, eastern transepts, presbytery, and the Trinity Chapel of Canterbury Cathedral. Roman numerals are the Corpus Vitrearum catalogue numbers (1981). Those with the letter G refer to numbers assigned by Gostling (1777). Italics indicate lost glass (after Caviness, *Windows of Christ Church*, 9)

Fig. 14 | *The Last Judgment,* from the east window of the Trinity Chapel clerestory, Canterbury Cathedral, before 1207. Colored glass and vitreous paint, roundel, 79 × 82.5 cm (31⅛ × 32½ in.). Richmond, Virginia Museum of Fine Arts, Adolph D. and Wilkins C. Williams Fund, 69.10

The Last Judgment, or Second Coming, would have interrupted the sequence of the Ancestors of Christ series and appeared above the Redemption Window in the Corona at the lower level, in which Christ is resurrected and ascends to heaven. The figure of Christ and many of the heads were replaced in the twentieth century.

Choir; further, the genealogy of Christ may have been a theme used in the earlier choir. At some point during the planning and reconstruction of the new choir, the decision was made to extend the east end to increase the size of the Trinity Chapel to create an appropriate space for Becket's shrine.[35] Because the new scheme had four more windows than the earlier one, eight figures based on Matthew were included to fill out the sequence.

The significance of Luke's genealogy for the monks at Canterbury would have been more profound than the simple need to have more names to fill a vast space. Since the third century some theologians have considered the genealogies to be symbolic, with Matthew's representing Christ's royal character—the genealogy being traced through David's son Solomon and the subsequent kings of Judah; and Luke's signifying Christ's priestly role—the genealogy traced through another one of David's sons, Nathan, who was considered a prophet.[36] Luke's extensive genealogy also references all people from Creation, not just the descendants of Abraham and Isaac as listed in Matthew.

The symbolism of highlighting the priestly ancestry would have had particular relevance at Canterbury, where the archbishops had been in conflict with the monarchy since the time of Anselm, a dispute that climaxed with the martyrdom of Becket. He was murdered on December 29, during the Christmas season, which is marked at the beginning and end by separate readings of the two genealogies. Matthew's is read before the Mass on Christmas Eve, heralding the birth of Jesus, the "son of David," being descended from the Jews; Luke's is read before the Mass on the eve of the Epiphany, heralding the manifestation of Christ to the Gentiles, all people; therefore, the full genealogy from Adam is appropriate.

The more inclusive genealogy in Luke also reflected the works of Anselm, who wrote one of his most important books, *Cur Deus homo* (Why a God-Man?), while he was archbishop. The treatise was meant to convince "not only Jews but even pagans" of the potential acceptability of all people to God and the preparation for the Last Things.[37] The clerestory window at the east end of the Trinity Chapel included a scene of the Last Judgment (fig. 14).[38] The series references the historical ancestors of Christ as symbolic precursors of the Messiah; the history of humanity's fallen nature through original sin from Adam and inherited through the generations to Jesus, the redeemer of that sin;[39] and the witness of history gathered for the Second Coming of Christ (Caviness discusses the multiple meanings of the genealogy in her essay herein).

Luke's genealogy worked well in relationship with the popular medieval theme of the Six Ages of This World:[40] the first age from Adam to Noah; the second from Noah to Abraham; the third from Abraham to David; the fourth from David to the time of captivity in Babylon; the fifth from the return from exile (led by Zorobabel, who laid the foundation of the Second Temple in Jerusalem) to the coming of Christ; the sixth from Jesus to the Second Coming. A seventh age would be not of this world but of eternity after the Last Judgment. The clerestory scheme at

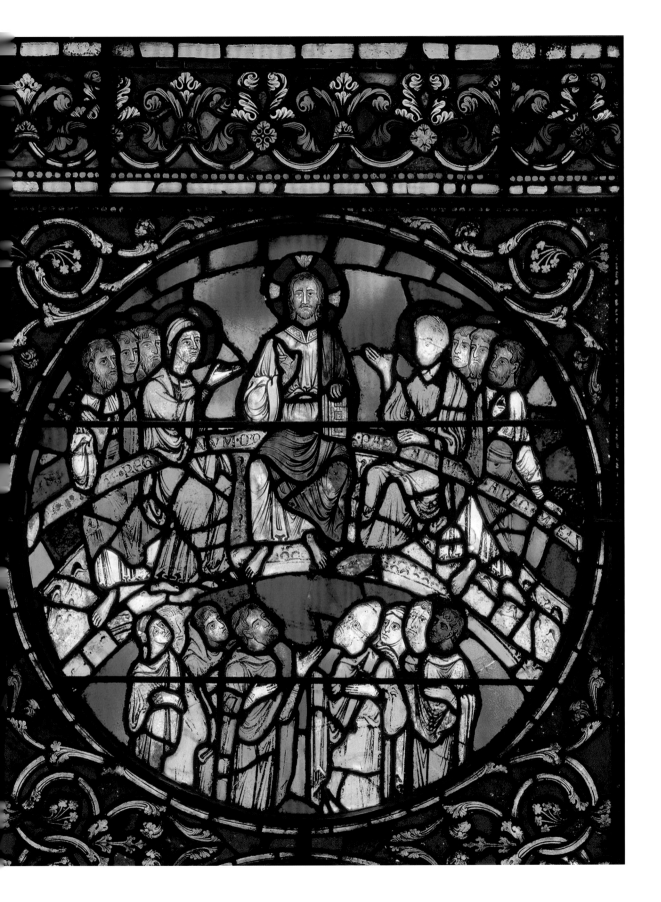

Canterbury may have been meant to conform roughly to the Six Ages of This World divisions: the first age (Adam to Lamech, father of Noah) along the north wall of the choir proper; the second age (Noah to Abraham) in the northeast transept (Gostling lists Abraham in the last window of the east wall before the turn into the presbytery[41]); the third age (to David) along the north wall of the presbytery and the Trinity Chapel; the fourth age (Nathan to Salathiel) around the end of the Trinity Chapel and along the south wall of the presbytery; and the fifth age (Zorobabel to Christ) through the southeast transept and along the south wall of the choir proper.

Seated male figures representing prophets, apostles, saints, and the Elders of the Apocalypse are seen throughout Early Christian and medieval churches. Yet at Canterbury, the Ancestors of Christ theme based on Luke may have had associations with the teachings of Anselm, and the representation of large-scale figures may also have had a specific source—the decoration in Old Saint Peter's Basilica in Rome.[42] From its completion in the fourth century to its demolition in the sixteenth century, Old Saint Peter's was a model for church decoration throughout Europe.[43] Canterbury as the seat of the English primate had strong associations with Old Saint Peter's. The basilica form of the initial Roman building on the site, having a high altar raised above a crypt housing the relics of saints, was a reflection

Fig. 15 | *Nave Wall of Old Saint Peter's Basilica*, by Domenico Tasselli, 1605. Ink and watercolor, 42.5 × 57 cm (16¾ × 22⁷⁄₁₆ in.). Vatican City, Biblioteca Vaticana, Archivo del Capitolo di San Pietro, A. 64 ter, fol. 12

of the layout of Old Saint Peter's,[44] the only Early Christian church that enclosed the shrine of a martyr.[45] Anselm presided over the five-hundredth anniversary of the founding of Canterbury in 1096 and began the construction of his choir that year, increasing the length of the church to match that of Old Saint Peter's.[46] The wall decoration in Old Saint Peter's included frescoes of monumental paired portraits of prophets and saints between the clerestory windows. Below were narrative cycles based on the Old and New Testaments (fig. 15).[47] The same themes are echoed at Canterbury with the large ancestors in the clerestory and the smaller narrative scenes in the aisle windows below.

The Development of the Figures

Representing large-scale figures in the top windows, some sixty feet above the pavement of the choir, was a challenge since images viewed from such a distance need to be large to be understood clearly from the floor. Each lancet therefore contained just two figures placed one above the other, usually with the earlier of the two subjects from the genealogy in the upper part of the window. Most are represented seated and gesturing or turning toward the east. All have a large name band running behind the head that makes them identifiable from a distance. Few have specific attributes, their identification relying mostly on the names given. Apart from these general shared characteristics, the representations of the figures vary considerably over the course of the series. Caviness notes three broadly defined glazing campaigns that developed in sequence from the beginning of the reconstruction in 1174 to the early part of the thirteenth century, when the glazing of the Trinity Chapel was completed.[48] The glazing of the clerestory followed the progress of the construction of the new choir—beginning at the west end of the choir proper, continuing in the eastern transepts and presbytery in the center, and terminating with the Trinity Chapel at the east end of the church.[49] This means that the initial and concluding figures from the genealogy were produced at the same time and share early stylistic features, while the ancestors from the middle of the sequence were produced last, in a later style.

The first campaign of glazing was in the choir proper, where the windows are attributed to a single artist referred to as the Methuselah Master, named after *Methuselah* (fig. 16).[50] In addition to it, *Adam, Enoch, Jared,* and *Lamech* (figs. 12, 17, 28, and 31) are all attributed to this master and represent the earliest style in the clerestory glazing. His figures have a monumental, almost sculptural, gravity in the rendering of the draped bodies, which convey an imposing sense of presence. Equally impressive is the degree of psychological animation expressed in each unique character, while the group retains an overall feeling of substance and poise.

The Methuselah Master also produced some of the smaller narrative panels for the windows in the choir aisles below. Although necessarily different in scale from those in the clerestory, his figures in the lower windows are executed with

Fig. 16 | *Methuselah*, from the Ancestors of Christ Windows, Canterbury Cathedral. Attributed to the Methuselah Master, 1178–80. Colored glass and vitreous paint, 143.5 × 69.2 cm (56½ × 27¼ in.), S. XXVIII, 2–3e

According to the book of Genesis in the Old Testament, Methuselah lived 969 years, the longest of any ancestor of Christ. Although not represented here as an old man, the figure is shown in the pose of an ancient philosopher, symbolic of the wisdom that comes with age. This figure is exceptionally well preserved.

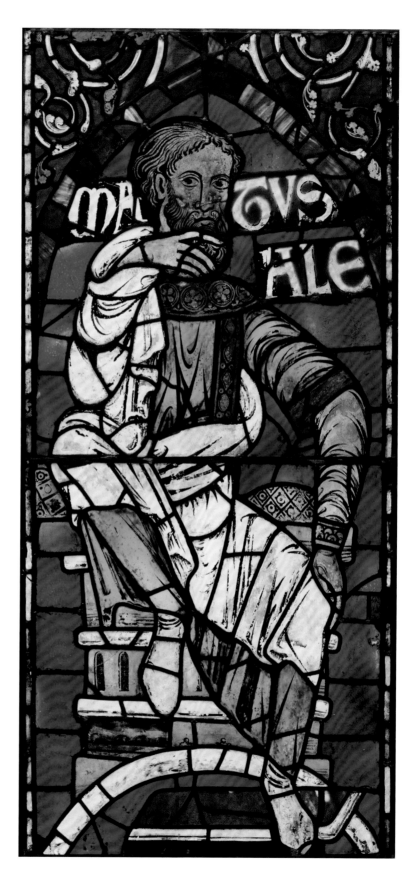

Fig. 17 | *Enoch,* from the Ancestors of Christ Windows, Canterbury Cathedral. Attributed to the Methuselah Master, 1178–80. Colored glass and vitreous paint, 144.3 × 71 cm (57 × 28 in.), S. XVIII, 2–3h

The son of Jared and the father of Methuselah, Enoch is unique among the generations since Adam listed in the book of Genesis in that he does not die but is taken up by God. Here the hand of God grabs Enoch's arm to pull him up to heaven. The scene is considered a type, or prefiguration, of the Ascension of Christ. The face is a twentieth-century replacement.

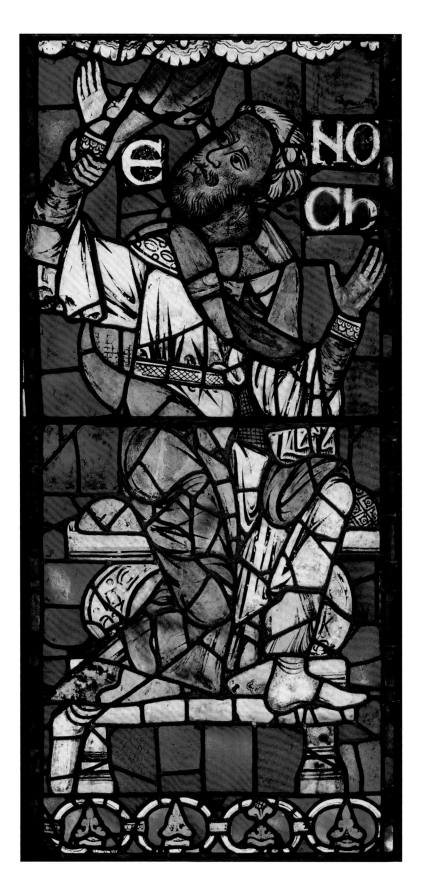

Fig. 18 | *The Three Magi before Herod*, from the St. Albans Psalter, St. Albans Abbey, England. Attributed to the Alexis Master, ca. 1130. Tempera and gold leaf on parchment, 27.5 × 18.5 cm (10⅞ × 7¼ in.). Dombibliothek Hildesheim, HS St. God. 1, p. 23

Herod, the Roman king of Judea, sitting on his throne in Jerusalem, instructs wise men from the East to search for the Christ child. They then follow a star, shown above, to Bethlehem.

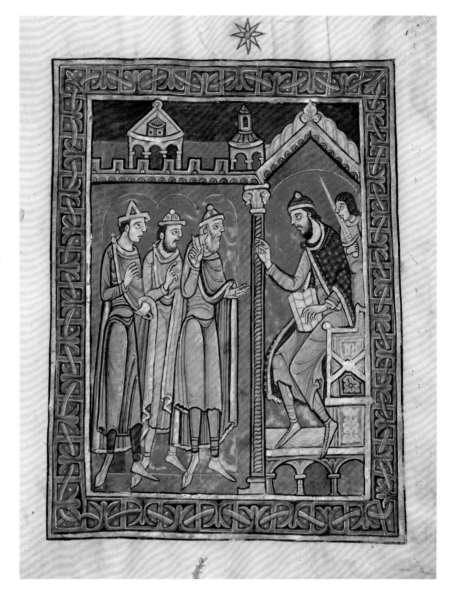

the same weight and emotional engagement.[51] This artist was responsive to the trends of painting in England and northern France, and something of the legacy of the Alexis Master can be seen in comparing the massing and articulation of the figures in *The Three Magi before Herod* from the St. Albans Psalter (fig. 18) with the same subject represented by the Methuselah Master in one of the aisle windows at Canterbury (fig. 19). The grouping, spacing, and sense of interaction between the figures are similar in the two works. The Methuselah Master's rendering, however, is more successful in expressing the corporeal weight and movement of the bodies, an accomplishment indicative of the advances made in English painting since the St. Albans Psalter was created earlier in the same century.

Apart from the group of figures in the choir, no other windows from the clerestory series can be attributed to the Methuselah Master, which suggests that he left

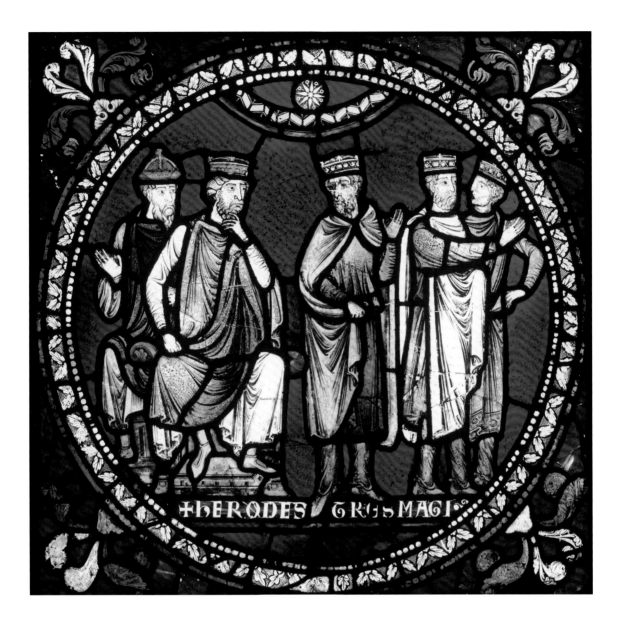

Fig. 19 | *The Three Magi before Herod*, from the Second Theological Window in the north choir aisle, Canterbury Cathedral. Attributed to the Methuselah Master, 1178–80. Colored glass and vitreous paint, 69 × 70.5 cm (27⅛ × 27¾ in.), n. XV, 33

By the Middle Ages the wise men mentioned in the Gospel of Matthew were described as Magi and commonly represented as three kings. Since they could sit in judgment of their subjects, kings were considered wise men. Here the Magi are shown crowned and of equal stature and bearing to Herod, while a star shines above. The panel is exceptionally well preserved.

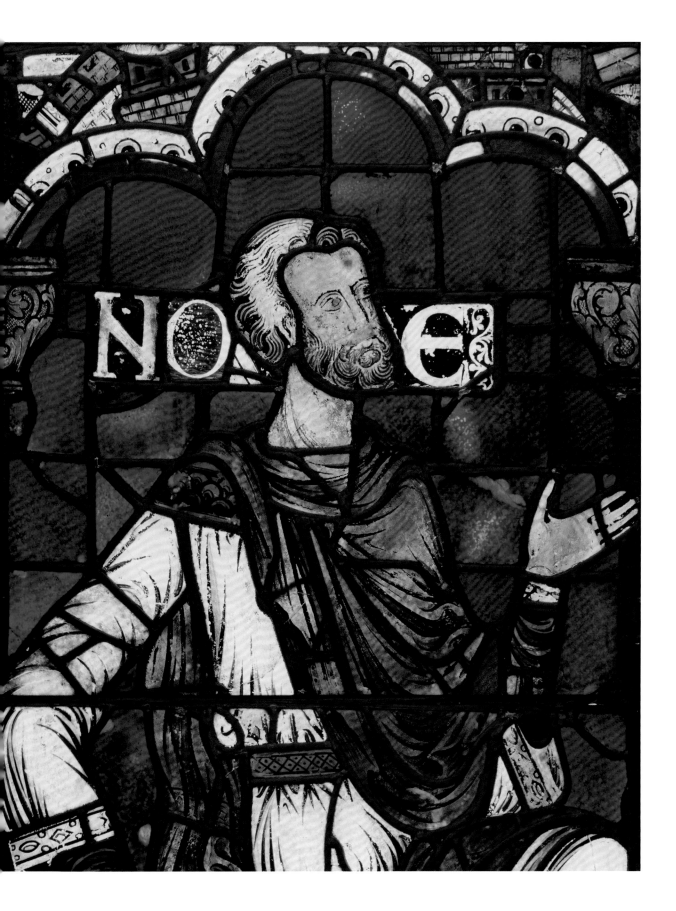

Fig. 20 | *Noah*, from the Ancestors of Christ Windows (detail, fig. 35).

Fig. 21 | *The Monk Eadwine*, from the Eadwine Psalter, Canterbury Cathedral, ca. 1150–60. Ink and pigments on vellum, 46 × 32.7 cm (18⅛ × 12⅞ in.). Cambridge, Trinity College Library, Ms R. 17.1, fol. 283v

The Eadwine Psalter was produced in the monastery at Canterbury Cathedral by the monastic scribe Eadwine, among others. This remarkable portrait is indicative of the monumental painting style then prevalent at Canterbury (see the wall painting *Saint Paul and the Viper*, fig. 11).

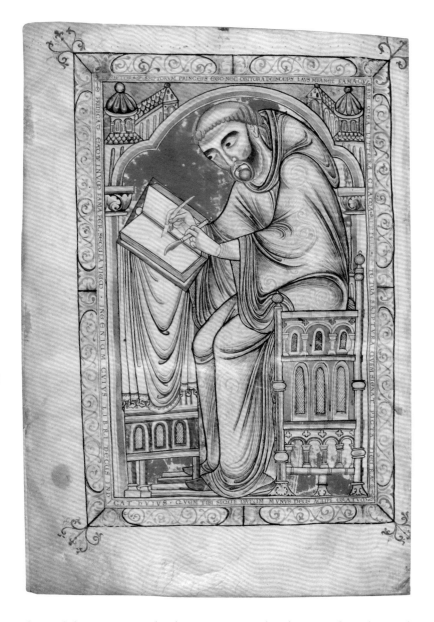

the workshop as soon as the choir proper was glazed. He may have designed *Noah* (fig. 20), originally in the first window of the northeast transept.[52] This figure has many of the same qualities as his other works, but Caviness notes that the execution of the painting is by a different hand.[53] The windows in the eastern transepts are slightly taller than those in the choir so, while here Noah is similar in size to the figures in the choir, more space remains above the head than in the other group. In *Noah* pilasters are represented along each side, supporting a trilobed arch over the figure. The design feature of an arch or a canopy appears to be the earliest such example depicted in stained glass. A possible source for the motif could be the portrait of the author in the Eadwine Psalter, which was painted in Canterbury circa 1150–60 (fig. 21), one indication that the glass painters appropriated elements seen in Canterbury manuscripts.[54]

The second style of figures in the clerestory is found in the windows from the eastern transepts and first two bays of the presbytery—the area that would be finished by Easter 1180. These windows were executed not by one artist but rather by a number of painters, possibly guided by a single designer. Figures such as *Phalec, Thara,* and *Abraham* (see figs. 40, 42, and 45) are less dynamic than those by the Methuselah Master. They are seated under canopies and most hold a scroll. Their proportions are attenuated and appear to have been designed with a consciousness of the foreshortened view of them that would be obtained by observers at the pavement level. Overall, these figures seem more static than those from the choir, and Caviness notes that some exhibit simplified facial features and costumes.[55] The less-detailed painting may indicate a need for haste in finishing the windows to keep up with the vaulting of the space.[56] It may also signal an awareness on the part of the designer that the level of finish and detail achieved by the Methuselah Master was not necessary for figures seen at such a distance.

The third broad style group is in the eastern part of the presbytery and the whole of the Trinity Chapel—the area completed after the erection of the temporary wooden wall behind the high altar in 1180. The production of the windows in this section probably stretched into the early years of the next century, certainly to be finished in time for the dedication of Becket's shrine in 1220. Here the figures are quite varied and evidently not the products of a single designer. *Naasson* from the presbytery (fig. 22) is still large and the figure is seated under an arch, but the composition and palette are markedly different from the designs of the second group of windows in the eastern transepts. The rendering of the arch, name band, and seat is more schematic, linear, and graphic than in the earlier figures. The colors are more delicate, and the distinctive red circles in the background give the entire surface a flat, decorative aspect.[57] The effect is refined and elegant, and less monumental and sculptural. *Naasson* is attributed to the so-called Petronella Master, named for one of the artists who contributed to the painting of the narrative scenes in the ambulatory windows representing the miracles associated with pilgrimage to Becket's tomb. This artist seems to have also worked in France (see Caviness herein).

In the Trinity Chapel there was a major change in design. Although still having one figure above the other in a sequence, the windows in this section are narrower and slightly taller than those in the rest of the clerestory, including windows paired within single bays forming a tight grouping in the shrine section of the church. The figures neither dominate the compositions nor are represented under arches as before. Here the ancestors are smaller and placed within shaped fields—geometric, lozenge, or quatrefoil—set within extensive ornamental backgrounds, some with narrow decorative borders. The overall effect of the closely positioned clerestory windows of the Trinity Chapel is decorative, their design resembling that of Mosan enamels and metalwork being produced in nearby Flanders. Indeed, there may have been a conscious attempt to model this most precious area of the church on an enameled and jeweled reliquary.

Fig. 22 | *Naasson*, from the Ancestors of Christ Windows, Canterbury Cathedral. Attributed to the Petronella Master, late twelfth century. Colored glass and vitreous paint, 140 × 50.5 cm (55⅛ × 19⅞ in.), W. 2b

Nahshon (Naasson) is listed in the book of Numbers of the Old Testament as the head of the tribe of Judah, one of the representatives from twelve tribes that Moses called to lead the Israelites through the wilderness of Sinai toward the promised land. The glass and paint have resisted decay to a degree that is unique at Canterbury. The painter had previously worked in France and may have brought a supply of glass with him.

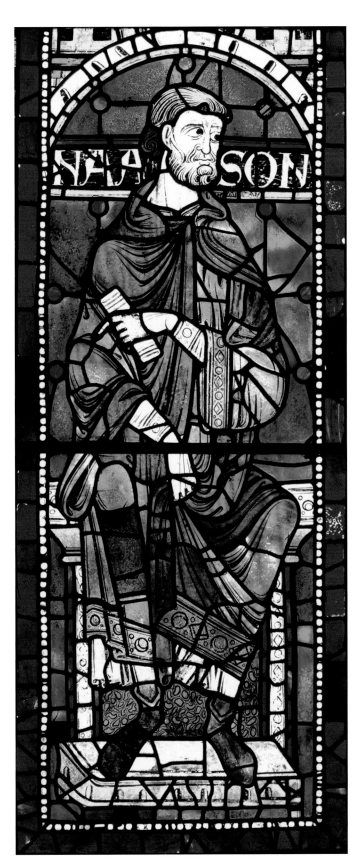

Fig. 23 | *Ezekias*, from the Ancestors of Christ Windows, Canterbury Cathedral, probably 1213–20. Colored glass and vitreous paint, 155 × 66 cm (61 × 26 in.), S. XXVIII, 7–8c

The book of Isaiah in the Old Testament tells how Hezekiah (Ezekias), a king of Judah, fell ill as Jerusalem was besieged by the Assyrian king. God answered Hezekiah's faithfulness and fervent prayer by turning back the shadow of his father's sundial, causing Hezekiah to recover so he could save the city. Hezekiah then sang a famous hymn of thanksgiving to the Lord. Here he is represented holding his attribute, a sundial.

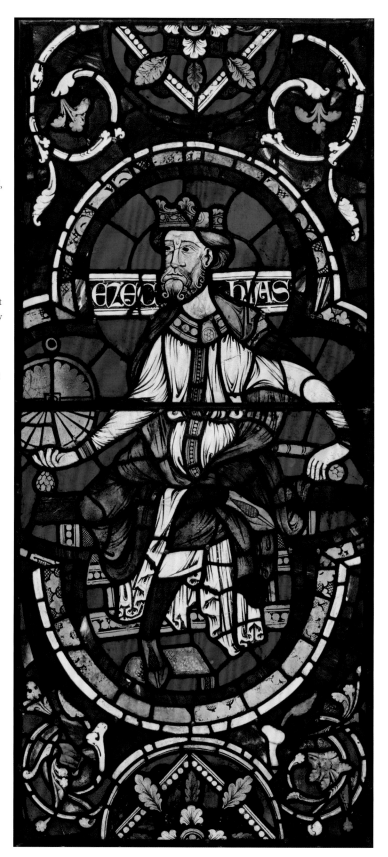

The floor level of the Trinity Chapel is the highest in the cathedral so there is less space between the pavement and the vaulting here than in the rest of the church. The area is also narrower, creating an intimate and integrated environment in which pilgrims have a closer view of the upper windows than they do elsewhere (see fig. 9). As a result, the clerestory windows in this section no longer required large-scale designs. And, since these upper windows are also seen in closer proximity to the ambulatory windows below, the smaller-scale decoration corresponds well with the designs of the lower windows.

The development of the ancestor figures in the Trinity Chapel is not consistent and it seems that they are the work of several artists. *Ezekias* (fig. 23) is one of the most successful of the surviving examples from this group. As it exists today, *Ezekias* is no longer seen in the full quatrefoil field since the sides were cut away when the panel was removed from the clerestory in the late eighteenth century.

Detail, fig. 23

Nevertheless, the figure is modeled with an expressive gesture and active pose recalling the figures by the Methuselah Master in the choir while retaining the elegant and decorative qualities seen in *Naasson* (see fig. 22), from the presbytery.

Caviness has noted that four of the figures in the Trinity Chapel—*David, Nathan, Roboam* (fig. 24), and *Abia*—are different in style from any others in the clerestory series.[58] The latter two especially, with their large heads and hands, are comparable to extant wall paintings in a crypt chapel at Canterbury that are thought to date about 1155–60 (fig. 25). The suggestion is that they may be survivals from the building before the fire of 1174 that were reused in the glazing of the Trinity Chapel, although *reuse* is too pedestrian a term for objects that may have been considered precious remnants. Their diminutive size would have fit, and may indeed have inspired, the new designs of the chapel clerestory windows.[59] As actual or perceived survivals from Anselm's Glorious Choir, these panels could have been highly valued as appropriate treasures to incorporate into the decoration of the Trinity Chapel, intended to house Becket's shrine, since they were similar in character to the jewels and rare objects that ornamented the golden shrine itself.

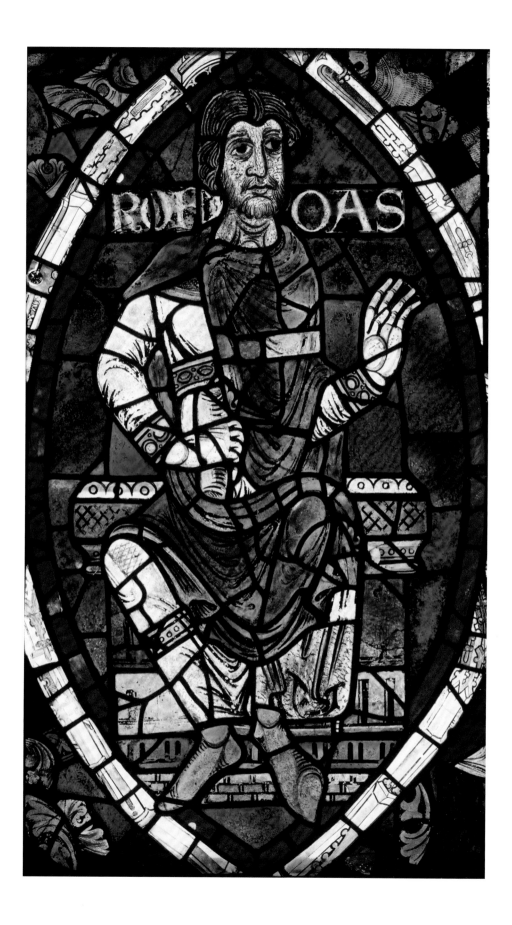

Fig. 24 | *Roboam*, from the Ancestors of Christ Windows, Canterbury Cathedral, possibly third quarter of the twelfth century. Colored glass and vitreous paint, 118.5 × 68.5 cm (46⅝ × 27 in.), W. 5c

According to the Old Testament, Rehoboam (Roboam) ruled the kingdom of Judah after the reign of his father, King Solomon. Rehoboam's sinful conduct led to the plunder of Jerusalem and the Temple by the Egyptian king and to continual wars with the other peoples of Israel. His negative legacy may be the reason he is represented without a crown in this window. The head dates from a twentieth-century restoration.

Fig. 25 | *The Naming of the Infant John the Baptist*, wall painting in Saint Gabriel's Chapel, Canterbury Cathedral, 1155–60

The first chapter in the Gospel of Luke tells how the angel Gabriel announced to the elderly priest Zechariah that his wife would bear a son. Zechariah expressed doubt and for his disbelief was struck mute. After the child was born, and Zechariah was asked to name him, Zechariah wrote on a tablet, "His name is John"; he then regained his speech. Zechariah is shown seated at the right, writing this text.

The Surviving Figures from the Ancestors of Christ Windows

Forty-three individual figures from the Ancestors of Christ series, or half the original group, which probably numbered eighty-six, survive today. Most of them were removed in the late eighteenth century and transferred to either the west window of the nave (Great West Window) or the southwest transept window (Great South Window).[60] Only the figures were removed; seventeen original borders remain in the clerestory. Eight figures—*Shem, Heber, Isaac, Phares, Juda, Cosam, Neri,* and *Rhesa* (see diagram, fig. 13)—are still in the clerestory together with twentieth-century copies and reconstructions of many of the figures.

The Great West Window in the nave (fig. 26) now houses thirteen of the stained glass figures. Seven are along the bottom row, set between panels of later glass: (left to right) *Esrom, Naasson, Semei, Adam, Joseph, Aminadab,* and *Aram.* Six are along the base of the middle row, set below panels of later glass: (left to right) *Jechonias, Obed, Roboam, Abia, Jesse,* and *Salathiel.*

The Great South Window, in the southwest transept (fig. 27), now houses twenty-two of the figures, all set between panels of later glass. Eight are along the bottom: (left to right) *Lamech, Noah, Thara, Jared, Methuselah, Phalec, Ragau,* and *Enoch.* Six are along the middle row, three on each side of two modern figures in the center: (left to right) *Abraham, Salmon, Ezekias, Josias, Booz,* and *Zorobabel.* Eight are along the top row: (left to right) *Joanna, Er, Joseph?, David, Nathan, Achim?, Jose,* and *Juda.*

In July 2009 structural damage was discovered in the stonework of the Great South Window. The stained glass was immediately removed and safely stored and will be returned once the repairs to the stonework are complete. Four of the figures have been placed in rotation on public view in the cathedral crypt. Six of the ancestors (see figs. 28, 31, 35, 40, 42, and 45) and three sets of border panels (see figs. 33, 38, and 44) from the clerestory are included in the exhibition *Canterbury and St. Albans: Treasures from Church and Cloister* at the J. Paul Getty Museum in Los Angeles and in a display of the windows organized by the Metropolitan Museum of Art at the Cloisters in New York City.

Fig. 26 | The Great West Window at the west end of the nave, Canterbury Cathedral. 14.63 × 7.16 m (48 × 23½ ft.), W.

The nave was rebuilt during the late fourteenth century, and the architecture for the large, High Gothic window in the west wall was probably complete by 1400. The original glass in the lower half of the Great West Window was gone by the eighteenth century, when panels from the Ancestors of Christ series in the choir clerestory were transferred to the lower two rows.

Fig. 27 | The Great South
Window in the southwest
transept, Canterbury Cathedral.
15.86 × 7.32 m (52 × 24 ft.),
S. XXVIII

The structure for the Great
South Window was complete
by 1400. Almost all its original
glass, however, was gone by the
eighteenth century, when the
early panels from the Ances-
tors of Christ series from the
choir clerestory were installed
there, supplemented by later
heraldic glass, small figures, and
ornament.

NOTES

1. Gervase of Canterbury, "Tractatus de combustion et
 reparation cantuariensis ecclesiae," in *Gervasii Cantuariensis
 opera historica*, ed. W. Stubbs, Rolls Series 73 (London,
 1879–80), 1:3–29; R. Willis, *The Architectural History of
 Canterbury Cathedral* (London: Longman, 1845), 32–62;
 Francis Woodman, *The Architectural History of Canterbury
 Cathedral* (London: Routledge and Kegan Paul, 1981), 91–98.

2. Woodman, *Architectural History of Canterbury Cathedral*, 3.

3. William Gostling, *A Walk in and About the City of Can-
 terbury with Many Observations Not to Be Found in Any
 Description Hitherto Published* (Canterbury, England, 1777).

4. Madeline H. Caviness, *The Early Stained Glass of Canterbury
 Cathedral, Circa 1175–1220* (Princeton, NJ: Princeton Univer-
 sity Press, 1977).

5. Madeline H. Caviness, *The Windows of Christ Church
 Cathedral, Canterbury*, Corpus Vitrearum Medii Aevi, Great
 Britain 2 (London: Oxford University Press for the British
 Academy, 1981). For earlier studies of the windows, see
 Bernard Rackham, *The Ancient Glass of Canterbury Cathe-
 dral* (London: Lund Humphries for Friends of Canterbury
 Cathedral, 1949), and *The Stained Glass Windows of Canter-
 bury Cathedral* (Canterbury, UK: S.P.C.K., 1957).

6. The St. Albans Psalter Project (2003), King's College,
 University of Aberdeen, Scotland, Transcription/translation,
 www.abdn.ac.uk/stalbanspsalter/english/translation
 /trans068.shtml.

7. Ibid., www.abdn.ac.uk/stalbanspsalter/english/essays
 /miniatures.shtml#meditation.

8. See Madeline H. Caviness, "Biblical Stories in Windows:
 Were They Bibles for the Poor?," in *The Bible in the Middle
 Ages: Its Influence on Literature and Art*, ed. Bernard S. Levy
 (Binghamton, NY: Medieval and Renaissance Texts and
 Studies, 1992), 106.

9. See Conrad Rudolph, "Inventing the Exegetical Stained-
 Glass Window: Suger, Hugh, and a New Elite Art," *Art
 Bulletin* 93, no. 4 (December 2011): 417.

10. Gostling, *Walk in Canterbury*, 200.

11. Woodman, *Architectural History of Canterbury Cathedral*, 89.

12. For discussions of the architectural program, see ibid.,
 87–130; Paul Binski, *Becket's Crown: Art and Imagination in
 Gothic England, 1170–1300* (New Haven, CT: Yale University
 Press for the Paul Mellon Centre for Studies in British Art,

2004); and Peter Draper, *The Formation of English Gothic: Architecture and Identity* (New Haven, CT: Yale University Press for the Paul Mellon Centre for Studies in British Art, 2006), 13–33.

13. Woodman, *Architectural History of Canterbury Cathedral*, 94.

14. Madeline H. Caviness, "Canterbury Cathedral Clerestory: The Glazing Programme in Relation to the Campaigns of Construction," in *Medieval Art and Architecture at Canterbury before 1220*, British Archaeological Association: Conference Transactions for the Year 1979 (London: British Archaeological Association and Kent Archaeological Society, 1982), 53.

15. Woodman, *Architectural History of Canterbury Cathedral*, 94.

16. Draper, *Formation of English Gothic*, 15.

17. William of Malmesbury, *De gestis pontificum Anglorum libri quinque*, Rolls Series 52, ed. N. Hamilton (London: Longman, 1870), 138.

18. Woodman, *Architectural History of Canterbury Cathedral*, 23.

19. Jennifer L. O'Reilly, "The Double Martyrdom of Thomas Becket: Hagiography or History," in *Studies in Medieval and Renaissance History*, n.s. 7, ed. J. A. S. Evans and R. W. Unger (New York: AMS Press, 1985), 221.

20. T. A. Heslop, "St Anselm, Church Reform, and the Politics of Art," *Anglo-Norman Studies* 33 (2011): 103. See Madeline H. Caviness, "Romanesque 'belles verrières' in Canterbury?," in *Romanesque and Gothic: Essays for George Zarnecki*, ed. Neil Stratford (Woodbridge, UK: Boydell Press, 1987), 35–38.

21. Draper, *Formation of English Gothic*, 32.

22. Anne J. Duggan, "The Cult of St Thomas Becket in the Thirteenth Century," in *St Thomas Cantilupe Bishop of Hereford: Essays in His Honour*, ed. Meryl Jancey (Hereford, UK: Friends of Hereford Cathedral, 1982), 22.

23. Gostling, *Walk in Canterbury*, 113.

24. Madeline H. Caviness, "A Lost Cycle of Canterbury Paintings of 1220," *Antiquaries Journal* 54 (1974): 69.

25. Caviness, *Windows of Christ Church*, 159. For more on the creation of the Trinity Chapel and Becket shrine, see Sarah Blick, "Reconstructing the Shrine of St Thomas Becket, Canterbury Cathedral," 1:405–41 and 2:figs. 199–212, and Anne F. Harris, "Pilgrimage, Performance, and Stained Glass at Canterbury Cathedral," 1:243–81 and 2:figs. 124–33, in *Art and Architecture of Late Medieval Pilgrimage in Northern Europe and the British Isles*, ed. Sarah Blick and Rita Tekippe (Leiden, Netherlands: Brill, 2005).

26. Deborah Kahn, *Canterbury Cathedral and Its Romanesque Sculpture* (Austin: University of Texas Press, 1991), 22.

27. Caviness, "Romanesque 'belles verrières,'" 35.

28. C. R. Dodwell, *The Pictorial Arts of the West, 800–1200* (New Haven, CT: Yale University Press, 1993), 344.

29. Gostling, *Walk in Canterbury*, 323.

30. Ibid.

31. Caviness, *Windows of Christ Church*, 9.

32. For the iconographic program, see Caviness, *Early Stained Glass*, 101–6; and Caviness, *Windows of Christ Church*, 8–10.

33. The names in the genealogy of Christ as found in Luke are listed below. They are known by a number of variant spellings; the King James version is used here. UPPERCASE indicates surviving windows at Canterbury; underline indicates surviving windows in the clerestory.

 Jesus, being (as was supposed) the son of Joseph, Heli, Matthat, Levi, Melchi, Janna, Joseph, Mattathias, Amos, Naum, Esli, Nagge, Maath, Mattathias, SEMEI, JOSEPH, JUDA, JOANNA, RHESA, ZOROBABEL, Salathiel, NERI, Melchi, Addi, COSAM, Elmodam, ER, JOSE, Eliezer, Jorim, Matthat, Levi, Simeon, Juda, Joseph, Jonan, Eliakim, Melea, Menan, Mattatha, NATHAN, DAVID, JESSE, OBED, BOOZ, SALMON, NAASSON, AMINADAB, ARAM, ESROM, PHARES, JUDA, Jacob, ISAAC, ABRAHAM, THARA, Nachor, Saruch, RAGAU, PHALEC, HEBER, Sala, Cainan, Arphaxad, SEM, NOE, LAMECH, MATHUSALA, ENOCH, JARED, Maleleel, Cainan, Enos, Seth, ADAM, God.

34. The male names in the genealogy of Christ as found in Matthew are listed below. They are known by a number of variant spellings; the King James Version is used here. UPPERCASE indicates surviving windows at Canterbury; underline indicates surviving windows in the clerestory.

 ABRAHAM, ISAAC, Jacob, JUDAS, PHARES, ESROM, ARAM, AMINADAB, NAASSON, SALMON, BOOZ, OBED, JESSE, DAVID, Solomon, ROBOAM, ABIA, Asa, Josaphat, Joram, Ozias, Joatham, Achaz, EZEKIAS, Manasses, Amon, JOSIAS, JECHONIAS, SALATHIEL, ZOROBABEL, Abiud, Eliakim, Azor, Sadoc, ACHIM, Eliud, Eleazar, Matthan, Jacob, Joseph, the husband of Mary, of whom was born Jesus, who is called Christ.

35. For a discussion of this issue, see Peter Draper, "William of Sens and the Original Design of the Choir Termination of Canterbury Cathedral," *Journal of the Society of Architectural Historians* 42, no. 3 (October 1983): 238–48; M. F. Hearn, "Canterbury Cathedral and the Cult of Becket," *Art Bulletin* 76, no. 1 (March 1994): 19–52.

36. B. H. Throckmorton Jr., "Genealogy (Christ)," in *The Interpreter's Dictionary of the Bible* (New York: Abingdon Press, 1962), 2:366.

37. Heslop, "St Anselm, Church Reform, and the Politics of Art," 122–23.

38. Caviness, *Windows of Christ Church*, 311–12.

39. For Anselm's emphasis on the objective character of the transmission of original sin in Adam, see John Janaro, "Saint Anselm and the Development of the Doctrine of the Immaculate Conception: Historical and Theological Perspectives," *Saint Anselm Journal* 3, no. 2 (Spring 2006): 48–56.

40. For a description of the Six Ages of This World by the English monk Bede (ca. 673–735 CE), see *Bede: The Reckoning of Time*, trans. Faith Wallis, Translated Texts for Historians 29 (Liverpool: Liverpool University Press, 1999), 157–58.

41. Gostling, *Walk in Canterbury*, 326–27.

42. Heslop, "St Anselm, Church Reform, and the Politics of Art," 103, 107, n. 12.

43. Herbert L. Kessler, "'Caput et Speculum Omnium Ecclesiarum': Old St Peter's and Church Decoration in Medieval Latium," in *Italian Church Decoration of the Middle Ages and Early Renaissance: Functions, Forms and Regional Traditions*, ed. William Tronzo (Bologna: Nuova Alfa Editoriale, 1989), 119.

44. Woodman, *Architectural History of Canterbury Cathedral*, 16.

45. Richard Krautheimer, *Early Christian and Byzantine Architecture* (Harmondsworth, UK: Penguin, 1965), 36.

46. Heslop, "St Anselm, Church Reform, and the Politics of Art," 105.

47. Kessler, "Old St Peter's and Church Decoration," 122.

48. The summary of the stylistic progression in the glazing program adheres to Caviness's study of the glass in her publications *Early Stained Glass*, 49–82; *Windows of Christ Church*, 13–16; "Canterbury Cathedral Clerestory," 48–55; and *Sumptuous Arts at the Royal Abbeys in Reims and Braine: Ornatus Elegantiae, Varietate Stupendes* (Princeton, NJ: Princeton University Press, 1990), 13–16.

49. Caviness, *Windows of Christ Church*, 16.

50. Caviness, *Windows of Christ Church,* 14.

51. Caviness, *Windows of Christ Church*, 15.

52. Caviness, *Sumptuous Arts*, 14.

53. Ibid.

54. Caviness, "Canterbury Cathedral Clerestory," 52.

55. Caviness, *Sumptuous Arts*, 15.

56. Ibid.

57. Caviness, *Windows of Christ Church*, 16.

58. Caviness, "Romanesque 'belles verrières,'" 36.

59. Caviness, *Sumptuous Arts*, 16.

60. Caviness, *Windows of Christ Church*, 10. In the late nineteenth century copies of the surviving ancestor figures were made and placed in the clerestory; only four of those, however, survived World War II.

 Three panels from the clerestory survive in museums (see Caviness, *Windows of Christ Church*, appendix 1, 311–12): *Head of the Patriarch Semei* (London, Victoria and Albert Museum, acc. no. C.854–1920); *Saint Stephen Disputing with Jews* and *The Last Judgment* (Richmond, Virginia Museum of Fine Arts, acc. no. 69.10).

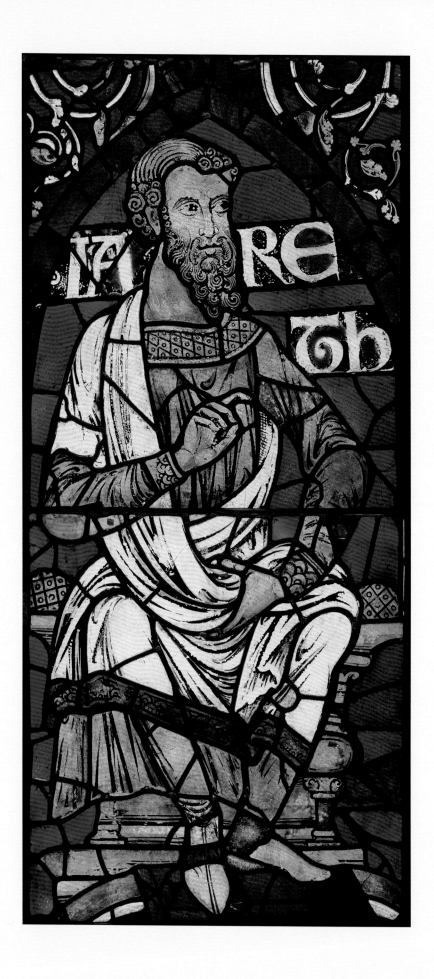

Selected Individual Figures from the Ancestors of Christ Windows

Jeffrey Weaver

JARED represents the fifth generation since Adam. The name is listed in the book of Genesis (5:15–20) and in the Gospel of Luke (3:37) as the son of Maleleel and the father of Enoch. The name band reads JAREТh, an alternate spelling.

Jared (fig. 28) is attributed to the Methuselah Master (see p. 29).[1] As with all that master's compositions for the clerestory, the figure dominates the image, almost touching each edge. Jared is seated on a golden, backless throne against a blue background with no further ornamentation. The figure is rendered in the confident manner typical of the Methuselah Master, with limited colors and bold masses. There is painting on both sides of the glass of the face and upper hand, where even the fingernails are delineated, contributing to the full modeling of the figurative details.

Elements of the costumes represented in the clerestory figures—particularly the wide decorative bands around the neck or shoulders, at the cuffs, and along the hems of gowns and cloaks—resemble aspects of contemporary twelfth-century dress for the ruling secular and ecclesiastical classes. Decorative bands heavily appliquéd with embroidery or jewel forms were typical of the time, as were the tight cuffs and ankle-

high shoes.[2] Jared is shown in a green gown with wide golden appliquéd borders at the neck and cuffs. The ensemble of long gown and cloak recalls contemporary ceremonial dress, which, although Roman in origin, was thought to be a reflection of the garments worn by the ancient priests and kings of the Old Testament who presaged the coming of Christ.[3]

The composition of *Jared* could be based on the images in a local manuscript copy of the Hexateuch (first six books of the Bible) in an Anglo-Saxon translation attributed to Aelfric that includes illustrations of the fifth chapter of Genesis, which lists the generations of Adam to Noah (fig. 29).[4] This English Hexateuch dates from the second quarter of the eleventh century and was probably made at Saint Augustine's Abbey, another Benedictine monastery in Canterbury. The illustrations of the generations of Adam follow the formula of the biblical text, "Jared lived after the birth of Enoch eight hundred years and had other sons and daughters. Thus all the days of Jared were nine hundred sixty-two years: and he died" (Genesis 5:19–20).[5] The picture shows Jared seated next to his wife; the former gestures to their son, the latter to their daughters. The next image shows Jared's burial with the wife supporting Jared's feet and the now-adult son and successor supporting his head. The Methuselah Master seems to have modeled his representations of Jared and Methuselah (see fig. 16) on the images of the seated figures of the same names in this manuscript.[6]

A similar composition is seen in the Methuselah Master's rendering of the seated Pharaoh in *The Exodus of the Israelites* (fig. 30), one of the narrative scenes he

Fig. 28 | *Jared*, from the Ancestors of Christ Windows, Canterbury Cathedral. Attributed to the Methuselah Master, 1178–80. Colored glass and vitreous paint, 148 × 68.5 cm (58¼ × 27 in.), S. XXVIII, 2–3d

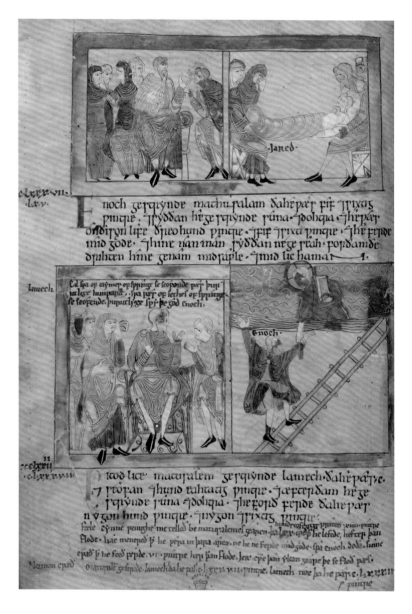

Fig. 29 | *Jared and Family* (upper left) and *Death of Jared* (upper right), *Enoch and Family* (lower left) and *Enoch Taken Up by God* (lower right), from the Anglo-Saxon Hexateuch known as the Cotton Aelfric, probably Canterbury, Saint Augustine's Abbey, second quarter of the eleventh century. Ink and pigments on parchment, 33.5 × 23 cm (13¼ × 9 in.). London, The British Library, Cotton MS Claudius B IV, fol. 11v

Fig. 30 | *The Exodus of the Israelites*, from the Second Theological Window in the north choir aisle, Canterbury Cathedral. Attributed to the Methuselah Master, 1178–80. Colored glass and vitreous paint, 69 × 70.5 cm (27⅛ × 27¾ in.), n. XV, 32

This scene depicts Moses leading the Israelites out of Egypt, away from Pharaoh; they followed a pillar of cloud by day and a pillar of fire by night. It is considered an Old Testament type, or prefiguration, of the Magi described in the Gospel of Matthew. The surrounding text notes that as the people were led by the pillar, so the Magi were led by the star, and that Christ shone as a light to both. The *Exodus* panel is next to *The Three Magi before Herod* (see fig. 19) in the same window. The panel is exceptionally well preserved.

produced for an aisle window below. The style of the images demonstrates the advance of English painting from the Saint Augustine's Hexateuch, to the introduction of a new figurative approach in the early twelfth century with the work of the Alexis Master in the St. Albans Psalter (see fig. 3), to the monumental handling of the figures in the works by the Methuselah Master at Canterbury. The latter represents a manifestation of the mainstream of English painting at the end of the twelfth century.

Jared was originally in the top half of the fourth clerestory lancet in the north wall of the choir proper

above *Enoch* (see fig. 17 and fig. 13, N. XXII). It was moved in 1792 to the Great South Window. The top corners of ornamental border, composed of old glass, must have been added at that time—when it was transferred from an arched lancet frame to the squared frame in the Great South Window. The figure is exceptionally well preserved, with minimal replacement to the glass, mostly in the area near the feet. The original border remains in the clerestory. It represents rising three-leaf palmettes in light purple and white set within white ellipses on a blue background between red edges.

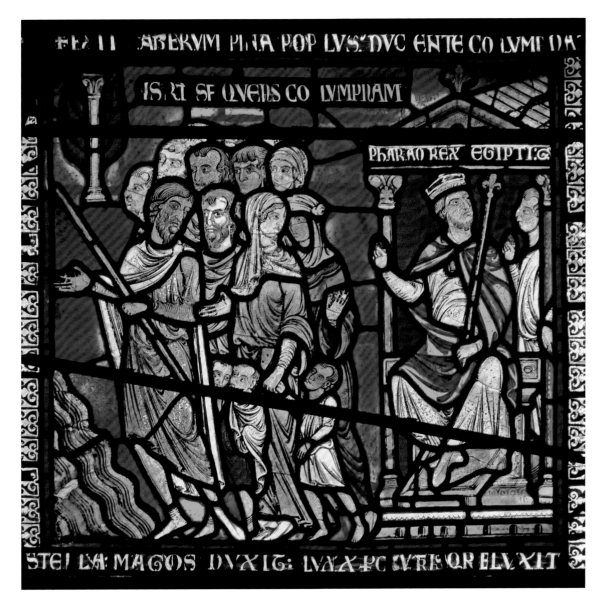

1. Caviness, *Windows of Christ Church*, 19–21.

2. I am grateful to Margaret Scott for this analysis. For twelfth-century decorative bands on clothing, see Janet Snyder, "The Regal Significance of the Dalmatic: The Robes of *Le Sacre* as Represented in Sculpture of Northern Mid-Twelfth-Century France," in *Robes and Honor: The Medieval World of Investiture*, ed. Stewart Gordon (New York: Palgrave Macmillan, 2001), 291–304. A pattern similar to that on the border on Jared's cuffs and cloak hem is seen in figure 13.2, p. 294, "Detail showing dalmatic heavy appliquéd hem of Porte de Valois R1, north transept portal of Saint-Denis." See also Janet Snyder, "Cloth from the Promised Land: Appropriated Islamic Tiraz in Twelfth-Century French Sculpture," in *Medieval Fabrications: Dress, Textiles, Clothwork, and Other Cultural Imaginings*, ed. E. Jane Burns (New York: Palgrave Macmillan, 2004), 147–64.

3. Michael Moore, "The King's New Clothes: Royal and Episcopal Regalia in the Frankish Empire," in *Robes and Honor: The Medieval World of Investiture*, ed. Stewart Gordon (New York: Palgrave Macmillan, 2001), 104–5.

4. London, The British Library, Cotton MS Claudius B IV (fol. 11v), an illuminated manuscript from the second quarter of the eleventh century with Latin and English annotations added in the late twelfth century, presumably at Saint Augustine's Abbey, Canterbury. It includes Aelfric's preface, Genesis, Exodus, Leviticus, Numbers, Deuteronomy, and Joshua.

5. A. N. Doane and William P. Stoneman, *Purloined Letters: The Twelfth-Century Reception of the Anglo-Saxon Illustrated Hexateuch (British Library, Cotton Claudius B. IV)*, Medieval and Renaissance Texts and Studies 395 (Tempe: Arizona Center for Medieval and Renaissance Studies, 2011), 276, and fig. 31a (fol. 11v), 282.

6. Caviness, *Windows of Christ Church*, 10, 20.

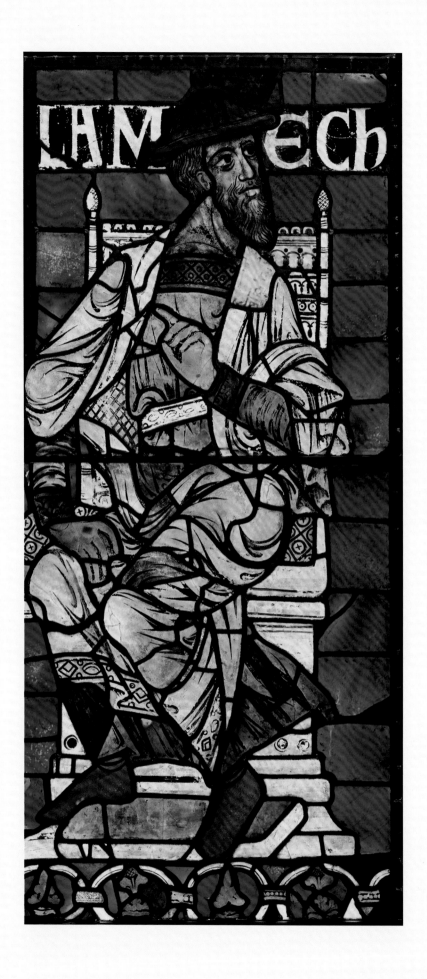

LAMECH represents the eighth generation since Adam. The name is listed in the book of Genesis (4:18–19, 23–24; 5:25–31) and in the Gospel of Luke (3:36–37) as the son of Methuselah and the father of Noah. The name band reads LAMECh.

Lamech (fig. 31) is the last figure in the Ancestors of Christ sequence attributed to the Methuselah Master (see p. 29).[1] As with the others, it fills the space and there is no ornamentation beyond the representation of the high-backed throne. Nevertheless, the way this figure is depicted is distinct from the calm stability of others, such as *Jared* (see fig. 28). Lamech conveys a nervous and unsettled energy with the torso and legs turned in opposite directions, and he wears the recognizable Jewish cap. This depiction is likely the result of Lamech's perceived sinful character and his pivotal placement in the genealogy.

In the Middle Ages, Lamech was negatively perceived as the father of Noah at the time of the increase of human sin before the Flood and the advent of the Second Age of This World.[2] Lamech's sinfulness and pride are reflected in his uneasy agitation and the

Fig. 31 | *Lamech*, from the Ancestors of Christ Windows, Canterbury Cathedral. Attributed to the Methuselah Master, 1178–80. Colored glass and vitreous paint, 148.8 × 70 cm (58½ × 27½ in.), S. XXVIII, 2–3a

Fig. 32 | *Moses and Jethro*, from the Third Theological Window in the north choir aisle, Canterbury Cathedral. Attributed to the Methuselah Master, 1178–80. Colored glass and vitreous paint, 118 × 79 cm (46½ × 31⅛ in.), n. XIV, 25

Moses, seated on a throne, listens to his father-in-law, Jethro, who urges him to appoint officers to help him rule. The New Testament parallel is the young Jesus listening to the teachers in the Temple. The text reads in part, "The humble are the pattern for the proud." The heads of Moses and the foreground figure at the right are twentieth-century replacements.

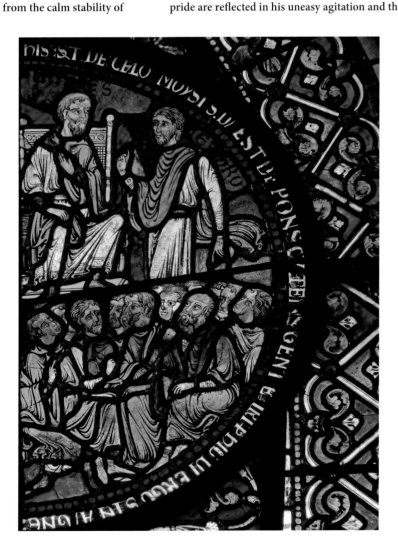

SELECTED INDIVIDUAL FIGURES

Fig. 33 | Panel from the border that originally framed *Methuselah* and *Lamech* (see figs. 16, 31) in the choir clerestory, Canterbury Cathedral, 1178–80. Colored glass and vitreous paint, 73 × 36.5 cm (28¾ × 14⅜ in.), N. XXI, 6

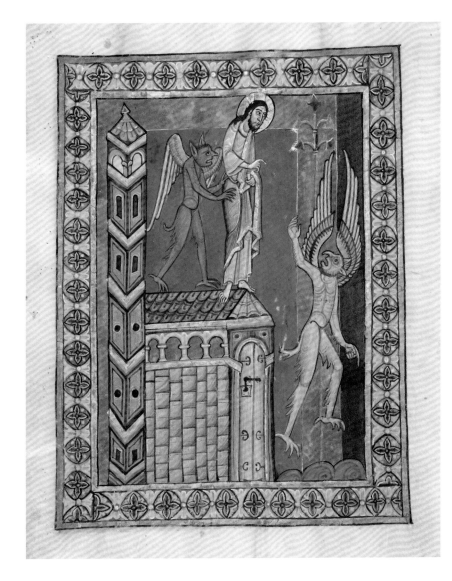

Fig. 34 | *The Second Temptation*, from the St. Albans Psalter, St. Albans Abbey, England. Attributed to the Alexis Master, ca. 1130. Tempera and gold leaf on parchment, 27.5 × 18.5 cm (10⅞ × 7¼ in). Dombibliothek Hildesheim, HS St. God. 1, p. 34

The devil places Jesus on the roof of the Temple in Jerusalem and dares him to jump off, saying that, since he is the Son of God, he will be saved. Jesus answered, "Do not put the Lord your God to the test" (Matthew 4:7, Luke 4:12).

ostentatious ivory throne. The distinctive pointed cap associated with the Jews may also punctuate the figure as symbolizing the end of the First Age of This World. A similar throne is seen in the Methuselah Master's *Moses and Jethro*, one of the narrative scenes from the aisle windows (fig. 32).

The original border for *Lamech* (fig. 33) remains in the clerestory. It is a comparatively simple pattern, like that around the figure of *Jared. Lamech*'s border comprises a series of white circles, each containing four leaves of light purple and green with yellow leaves between the circles, all on a blue background between red borders. Its design is similar in character to that of the border in *The Second Temptation* of the St. Albans Psalter (fig. 34).

Lamech was originally in the bottom half of the fifth clerestory lancet in the north wall of the choir proper below *Methuselah* (see fig. 16 and fig. 13, N. XXI). It was probably moved to the Great South Window in the 1790s. The neck, head, cap, and the letter E were replaced during the late nineteenth or early twentieth century; the rest of the figure is intact.

1. Caviness, *Windows of Christ Church*, 21–22.
2. Doane and Stoneman, *Purloined Letters*, 285, the text with an illustration of Lamech in the Saint Augustine's Hexateuch (Cotton MS Claudius B IV), "Just as from Cain's offspring the seventh, Lamech, was the most thoroughly bad, so of Seth's offspring the seventh was the most thoroughly good Enoch." Fig. 31b (fol. 12r), 283; see also pp. 271, 273.

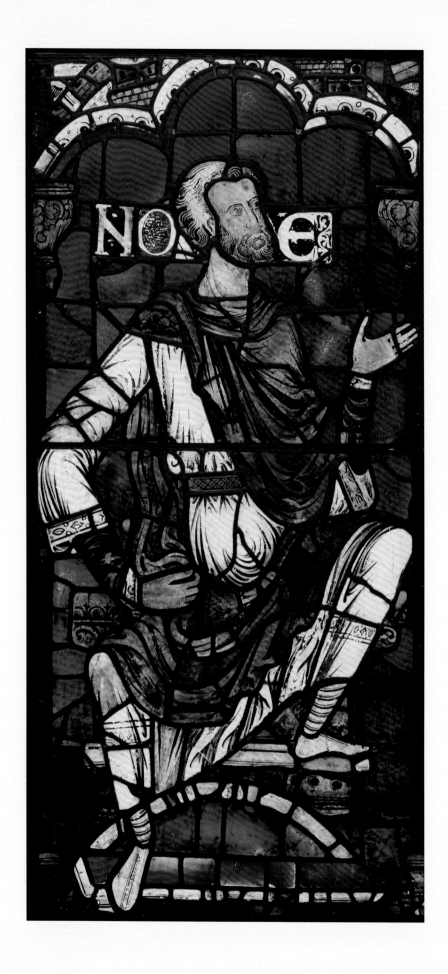

NOAH represents the ninth generation since Adam. The name is listed in the book of Genesis (5:28–32; 6:8–9:29) and in the Gospel of Luke (3:36–37) as the son of Lamech and the father of Shem. The name band reads NOE.

The design, though not the execution, of *Noah* (fig. 35) is attributed to the Methuselah Master (see p. 29), who apparently left the Canterbury workshop after the completion of the figures in the choir proper.[1] The composition is important for the trilobed arch above the figure, which spans two pilasters, the first such motif known in stained glass. The distinctive feature of the figure is that Noah is shown looking up

and is animated, as if in conversation, an appropriate action given that God spoke to Noah, instructing him to build the ark. The posture resembles that of an image of Noah in the eleventh-century Hexateuch from Saint Augustine's Abbey, Canterbury (see fig. 36), the same manuscript associated with the image of Jared (see fig. 28).[2] The Methuselah Master produced another animated depiction of Noah for one of the narrative scenes of the aisle windows (fig. 37).

The original border for *Noah* remains in the clerestory (fig. 38). It is more intricate than the borders that were around the figures of *Jared* and *Lamech* in the choir windows, the designs of which comprise the

Fig. 35 | *Noah*, from the Ancestors of Christ Windows, Canterbury Cathedral. Design attributed to the Methuselah Master, 1178–80. Colored glass and vitreous paint, 148.8 × 69.5 cm (58½ × 27⅜ in.), S. XXVIII, 2–3b

Fig. 36 | *Noah, Directed by the Hand of God, Stands between Wife and Three Sons* (left) and *Noah with Wife Flanked by Sons with Their Wives* (right), detail, from the Anglo-Saxon Hexateuch known as the Cotton Aelfric, probably Canterbury, Saint Augustine's Abbey, second quarter of the eleventh century. Ink and pigments on parchment; full page, 33.5 × 23 cm (13¼ × 9 in.). London, The British Library, Cotton MS Claudius B IV, fol. 12v

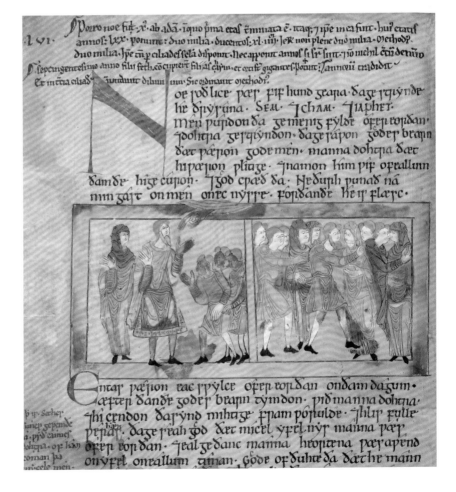

FLVAV CVNCTA VAGO
SV BMERGA NS PRIOA V
OMNIA PVRGAVI G
NOE IN ARChA

Fig. 37 | *Noah in the Ark*, from the Third Theological Window in the north choir aisle, Canterbury Cathedral. Attributed to the Methuselah Master, 1178–80. Colored glass and vitreous paint, panel with *Noah*: 118 × 79 cm (46½ × 31 in.), n. XIV, 11

Noah receives the olive branch from the dove. The ark symbolizes the church and is represented more like a building with a colonnaded clerestory than a boat. The text states the parallel with the New Testament: "The first Flood . . . purified everything and signified baptism." The panel is exceptionally well preserved.

linear repetition of a static motif. Here, the border is of a more organic design, with a white trellis pattern over rising thin yellow acanthus fronds around pink and white palmettes, all on a blue ground set between red edges. The motif of continuous growth is seen in the early-twelfth-century manuscript illumination *Mary Magdalene Announcing the Resurrection to the Disciples* from the St. Albans Psalter (fig. 39). The manuscript illustration also includes an arch with buildings above,

Fig. 38 | Panel from the border that originally framed *Shem* and *Noah* (see fig. 35) in the northeast transept, Canterbury Cathedral; 1178–80. Colored glass and vitreous paint, 85.6 × 36.8 cm (33¹¹⁄₁₆ × 14½ in.), N. XX, 6

Fig. 39 | *Mary Magdalene Announcing the Resurrection to the Disciples*, from the St. Albans Psalter, St. Albans Abbey, England. Attributed to the Alexis Master, ca. 1130. Tempera and gold leaf on parchment, 27.5 × 18.5 cm (10⅞ × 7¼ in.). Dombibliothek Hildesheim, HS St. God. 1, p. 51

After encountering the risen Christ in the garden, Mary Magdalene leaves and tells the disciples in Jerusalem, "I have seen the Lord" (John 20:18).

referred to as town canopies. Renderings of fragmented buildings are represented on the arch above *Noah*.

Noah was originally in the bottom half of the first clerestory lancet in the west wall of the northeast transept below *Shem* (see fig. 13, N. XX). It was probably moved to the Great South Window in the 1790s. Except for the lower hand, the figure is mostly intact, with minor replacements, and is well preserved except for the painting on the face, which is worn.

1. Caviness, *Windows of Christ Church*, 22–24.
2. Ibid., 24. London, The British Library, Cotton MS Claudius B IV, fol. 12v, shows Noah standing next to his wife while conversing with God above. See Doane and Stoneman, *Purloined Letters*, 35, and fig. 40 (fol. 12v), 353; see also p. 37 (fols. 13v and 14r, Noah speaking with God) and p. 39 (fol. 15v, the dove returns to the ark with a green branch, and Noah addresses God).

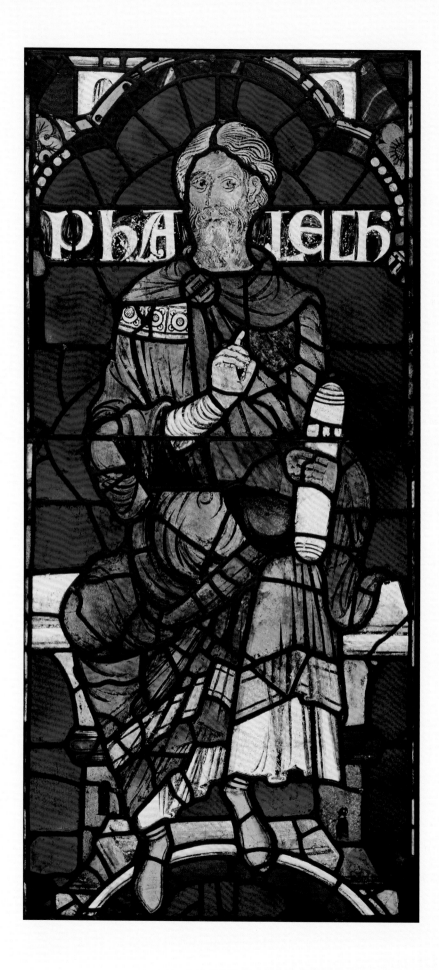

PHALEC represents one of the generations of Noah's son Shem. The name is listed as the fifth generation from Noah in the book of Genesis (10:25; 11:16–19) and the sixth generation from Noah in the Gospel of Luke (3:35); both list him as the son of Heber and the father of Ragau. The name band reads PhALECh.

Phalec (fig. 40) is attributed to the second style of figures in the clerestory, made after the Methuselah Master left the studio, by different painters, possibly working under the guidance of a single designer (see p. 36).[1] *Phalec* is representative of the second group, being shown as more rigidly frontal and compact in composition than the figures made by the Methuselah Master. The windows in this section of the church (the eastern transept and first two bays of the presbytery) are about a foot taller than those in the choir, so the figures are more attenuated than the earlier ones, either to better fill the higher space or to accommodate the foreshortened view from the pavement sixty feet below.

The figure holds a scroll, a generic symbol of authority and prestige rather than a specific attribute; most of the figures in this group are shown holding one. A slight distinction on *Phalec* is the representation of a large, round jeweled brooch fastening the cloak around the neck and the golden band at the shoulder. The decorative patterns on these two embellishments are drawn quite large, perhaps to make them somewhat legible from a distance. Otherwise, the decorative bands, yellow at the base of the gown and blue at the base of the cloak, are plain in contrast to the elaborately rendered bands on the costumes of the

Fig. 40 | *Phalec*, from the Ancestors of Christ Windows, Canterbury Cathedral, 1178–80. Colored glass and vitreous paint, 151.2 × 70.8 cm (59½ × 27⅞ in.), S. XXVIII, 2–3f

Fig. 41 | *Ecclesia and the Three Sons of Noah*, from the Sixth Theological Window in the northeast transept, Canterbury Cathedral. Attributed to the Master of the Parable of the Sower, 1175–80. Colored glass and vitreous paint, 68.5 × 71 cm (27 × 28 in.), n. XV, 12

The heads date from the twentieth century.

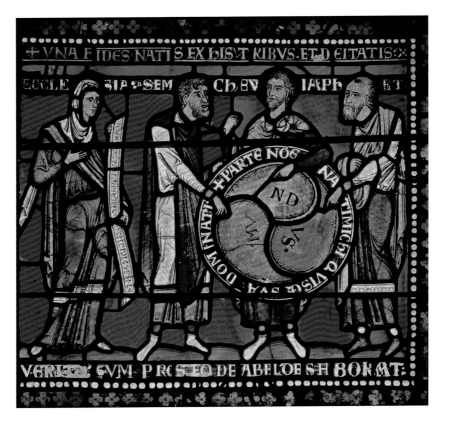

choir figures. The same is true of the backless throne, which is more simply rendered than a similar one in the window with *Jared* (see fig. 28).

It is noted in Genesis (10:25) that during Phalec's time the earth was divided. This reference could mean either the period after the Flood when Noah's descendants presided over the gathering of the peoples of the world into different lands (the Table of Nations), or the Tower of Babel story, in which God confuses the language of the people and they are scattered over the face of the earth. This stage during the Second Age of This World is the subject of the panel *Ecclesia and the Three Sons of Noah* (fig. 41), from one of the lower windows. The *Ecclesia* panel shows Noah's sons, Shem, Ham, and Japhet, after the Flood, pointing to three divisions of the world and stressing the unity of the faith with the text, which reads, "From these three sons is one faith in the Godhead."[2]

Phalec originally must have been in the top half of the first clerestory lancet in the east wall of the northeast transept above *Ragau* (see fig. 13, N. XVI), although Gostling records the pair in the third lancet of the same wall.[3] *Phalec* was probably moved from the clerestory in the 1790s. The top corners composed of old glass must have been added at that time—when it was transferred from an arched lancet frame to the squared frame in the Great South Window. Except for a few replacement pieces in the costume, the figure is intact and well preserved. The border does not survive.

1. Caviness, *Windows of Christ Church*, 29–30.
2. Caviness, *Windows of Christ Church*, 125.
3. Gostling, *Walk in Canterbury*, 326–27.

THARA represents the last of the generations of Noah's son Shem, before Abraham. The name Thara is listed as the ninth generation from Noah in the book of Genesis (11:24–32) and the tenth generation from Noah in the Gospel of Luke (3:34), identifying him as the son of Nachor and the father of Abraham. The name band reads ThARE.

The figure of *Thara* (fig. 42), like those of *Phalec* and *Abraham* (see figs. 40, 45), is attributed to the second style of figures in the clerestory (see p. 36).[1] Like Lamech (see fig. 31), who comes at the end of the First Age of This World, Thara also marks a pivotal point in the genealogy of Christ, at the end of the second age. As Lamech was from a time when sin had increased in the world, Thara was also popularly seen in a negative light, having come from Ur in Mesopotamia, a city considered to be a center of paganism.[2] The awkward gesture and tilt of the head convey a sense of unease, while the yellow cloak and Jewish cap are also seen on *Lamech*. Indeed, *Thara*'s head and cap seem to be closely modeled on those of the earlier figure. An unfavorable representation of a seated authority figure is also seen in *The Flagellation* from the St. Albans Psalter (fig. 43), which shows Pontius Pilate in the lower left corner wearing a pointed cap.

The original border of *Thara* remains in the clerestory (fig. 44). It consists of what appears to be a rather

Fig. 42 | *Thara*, from the Ancestors of Christ Windows, Canterbury Cathedral, 1178–80. Colored glass and vitreous paint, 148.5 × 70 cm (58½ × 27½ in.), S. XXVIII, 2–3c

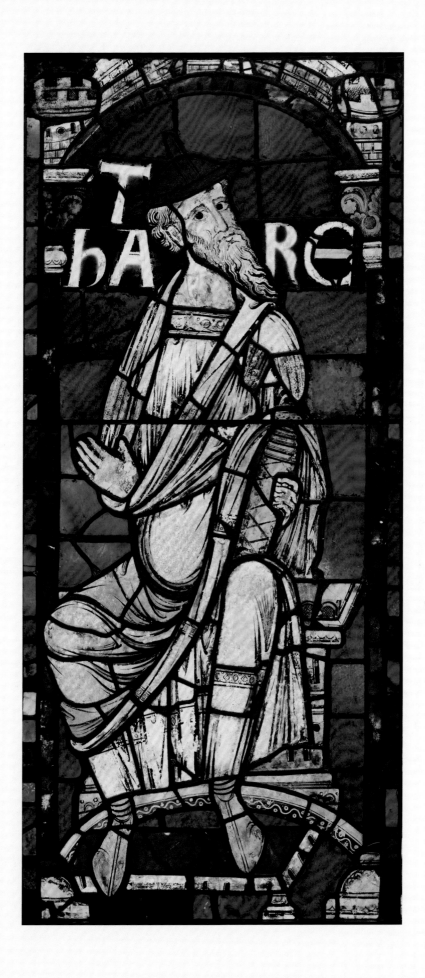

Fig. 43 | *The Flagellation*, from the St. Albans Psalter, St. Albans Abbey, England. Attributed to the Alexis Master, ca. 1130. Tempera and gold leaf on parchment, 27.5 × 18.5 cm (10⅞ × 7¼ in.). Dombiblilothek Hildesheim, HS St. God. 1, p. 44

Following the desire of the crowd, Pontius Pilate has Jesus flogged before handing him over for execution.

Fig. 44 | Panel from the border that originally framed *Thara* and *Abraham* (figs. 42, 45) in the northeast transept, Canterbury Cathedral, 1178–80. Colored glass and vitreous paint, 84.6 × 35 cm (33⁵⁄₁₆ × 13¹³⁄₁₆ in.), N. XIV, 6

simple organic design of surprising complexity. The dominant motif is a white trellis pattern formed by two stems rising in continuous growth forming ellipses, each of which contains a white and pink palmette of three leaves with a yellow stem. Two green leaves are at the contact points of the trellis pattern. The ground inside each ellipse is blue, and outside is red; all are set between blue edges.

Thara originally must have been in the top half of the third clerestory lancet in the east wall of the northeast transept above *Abraham* (see fig. 45 and fig. 13, N. XIV), though Gostling records the pair in the fourth and last lancet of the same wall.[3] *Thara* was moved to the Great South Window in 1792. The top corners composed of old glass must have been added at that time—when it was transferred from an arched lancet frame to the squared frame in the Great South Window. The figure is mostly intact and well preserved except for some wear in the painting of the face and a number of replacements along the edges.

1. Caviness, *Windows of Christ Church*, 30–31.
2. "And Joshua said to all the people, 'Thus says the Lord, the God of Israel: Long ago your ancestors—Terah and his sons Abraham and Nahor—lived beyond the Euphrates and served other gods'" (Joshua 24:2).
3. Gostling, *Walk in Canterbury*, 326–27.

ABRAHAM represents the beginning of the generations leading to David. The name is listed in the book of Genesis (11:26–25:11) and the Gospel of Luke (3:34) as the son of Thara and the father of Isaac. The Gospel of Matthew (1:1–2) begins the genealogy of Christ with this patriarch. The name band reads ABRAhO.

Abraham (fig. 45), like *Phalec* and *Thara* (see figs. 40, 42), is attributed to the second style in the clerestory windows (see p. 36) and has one of the most elaborate town canopies of the group.[1] Abraham does not hold an attribute, yet the figure reflects a sense of presence and stability, in contrast to Thara. A curious detail is the representation of the stockings. The lattice pattern enclosing crosses is similar to that on a pair of twelfth-century silk buskins that were found in the tomb of Archbishop Herbert Walter, who was buried at Canterbury in 1205 (fig. 46). Buskins were expensive stockings worn by upper-class gentlemen and high-ranking members of the clergy. The ankle-length slippers on Abraham also resemble a type of luxurious soft shoe worn by high clergymen at the time.[2]

Abraham, his son Isaac, and Isaac's son Jacob are the patriarchs of the Jewish people, being the spiritual ancestors of Judaism. The Gospel of Matthew begins the genealogy of Christ with Abraham, since Jesus, the "son of David," was of Jewish descent. In the Middle Ages the Christian Church also considered Abraham to represent the Third Age of This World. A panel in the aisle windows below shows *The Six Ages of This World* (fig. 47). In it Abraham is the third figure from the left, holding a sword and bowl of fire—which symbolize God's test in asking Abraham to sacrifice his son Isaac as a burnt offering to the Lord. That Abraham was willing to obey caused God to renew his promise to Abraham and his descendants, saying, "I will bless you and I will make your offspring as numerous as the

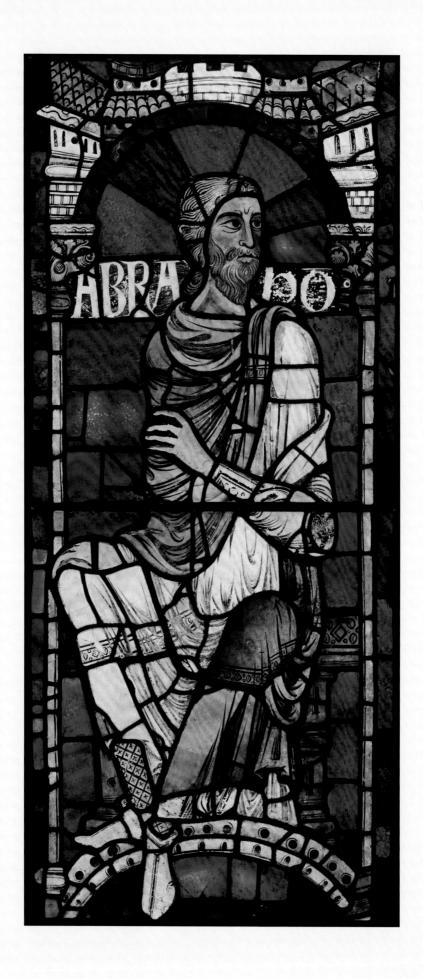

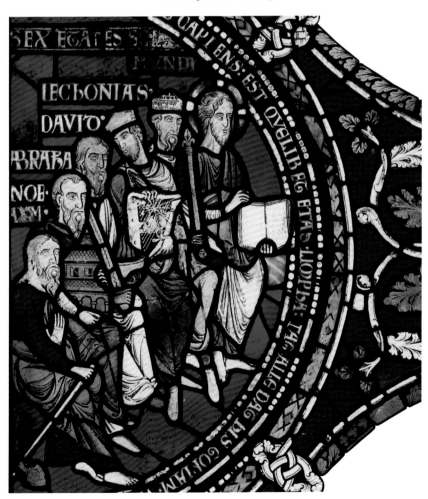

Fig. 45 | *Abraham*, from the Ancestors of Christ Windows, Canterbury Cathedral, 1178–80. Colored glass and vitreous paint, 155.9 × 68.8 cm (61⅜ × 27 in.), S. XXVIII, 7–8a

Fig. 46 | One of a pair of buskins, English, ca. 1170–1200. Embroidered silk, height: 68.6 cm (27 in.)

stars of heaven and as the sand that is on the seashore" (Genesis 22:17).

Abraham originally must have been in the bottom half of the third clerestory lancet in the east wall of the northeast transept below *Thara* (see fig. 42 and fig. 13, N. XIV), although Gostling records the pair in the fourth and last lancet of the same wall.[3] *Abraham* was moved to the Great South Window in 1792. A number of repairs have been made to the upper half of the figure, including the face, which was replaced in the early twentieth century, probably copied from the original. The lower half has only minor repairs. The border was the same as that for *Thara* (see fig. 44).

1. Caviness, *Windows of Christ Church*, 30–32.
2. Gale R. Owen-Crocker, Elizabeth Coatsworth, and Maria Hayward, eds., *Encyclopedia of Dress and Textiles in the British Isles c. 450–1450* (Leiden, Netherlands: Brill, 2012), 104, 322.
3. Gostling, *Walk in Canterbury*, 326–27.

Fig. 47 | *The Six Ages of This World*, from the Fourth Theological Window in the northeast transept, Canterbury Cathedral. Attributed to the Master of the Public Life of Christ, 1175–80. Colored glass and vitreous paint, 96.5 × 51.5 cm (38 × 20¼ in.), n. XIV, 18

The six ages are symbolized by (left to right) Adam, Noah, Abraham, David, Jechonias, and Christ. The panel parallels another one in the same window showing the Six Ages of Man represented by an infant, a youth, an adolescent, a young man, an adult, and an old man. The head of Christ is a twentieth-century replacement.

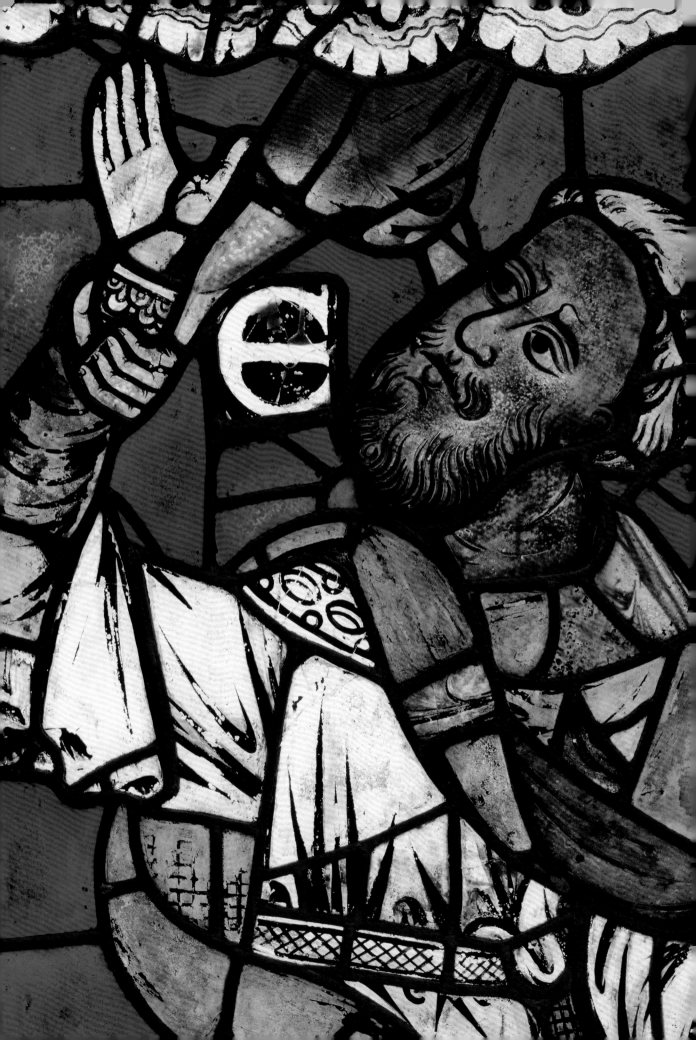

The Visual and Cognitive Impact of the Ancestors of Christ in Canterbury Cathedral and Elsewhere

Madeline H. Caviness

The life-size figures of the male ancestors of Christ that once looked down from the windows on the whole choir and eastern extension of the medieval cathedral and priory church of Canterbury epitomize many of the changing social and religious belief systems of the late twelfth century. The windows, filtering colored light into that interior space from its physical source, the sun, are a translucent membrane literally separating the exterior secular world of the family from the spiritual world of the monks in their places of worship. The Ancestors of Christ windows illuminated the liturgical areas during all but the earliest office in the depths of winter, glowing pale blue at dawn and warmer hues of yellow and red at noon. One of the paradoxes of stained glass is that it loses its life in the artificial light indoors; for the visitor to experience it fully, or even to photograph it, electric lights must be turned off. Such remoteness from our own lifestyle and expectations is just one aspect of the glass's alterity. This essay is about the multiple ways in which various medieval viewing communities might have perceived the monumental seated figures that constitute a genealogy of Christ, extending from father to son from the creation of Adam by the Father. Anyone entering the eastern parts of the church in the twelfth century was aware that the extended series of eighty-six seated figures reflected the attitudes and practices of its patrons and that it shaped a "community of lineage" among the viewers, who considered the biblical "Old Testament" past as its own.[1] Yet royals and lords, laypeople of the peasant or mercantile classes (some of them pilgrims from afar), princes of the church (archbishops and bishops), Jews from the local community, and the monks whose "house" the cathedral priory was could ponder different levels of meaning. They literally had different points of view according to their allowed place in the church, as well as disparate ways of understanding and interpreting what they could see or perhaps hear about. Similar programs elsewhere in Europe, placed in diverse contexts, likewise offered various resonances depending on the viewing communities.

Fig. 48 | *Enoch*, from the Ancestors of Christ Windows (detail, fig. 17)

As a sequence of fathers and sons, the Canterbury program is profoundly human, yet it lacks a maternal reference unless Christ's mother was in the last window with her son, as may have been the case. All societies have parenting arrangements that are central to family structures and inheritance, and established hierarchies that can enable smooth transitions from one generation to the next. Anthropologists distinguish societies according to whether genealogy is traced through the male or female line (patrilineal or matrilineal), whether a married couple lives in the husband's or the wife's homeland (patrilocal or matrilocal marriage), and whether inheritance favors a son (agnatic), perhaps the eldest (rule of primogeniture), or several sons and daughters.[2] Kingship, if it is hereditary, is most often agnatic. Societies marked by a preponderance of male privilege are loosely referred to as patriarchal. Such structures are often supported by religious belief systems and practices, although that authority does not necessarily hold them to a status quo. In fact, agnatic inheritance and primogeniture, which often drove landless younger sons to a career in the Church, were becoming norms in western Europe during the period when the Canterbury windows were being created. At the same time, since male royal blood lines were emphasized, queens were more likely to rule as regents for their eldest sons than in their own right. Many queens, including the English royalty, lived far from their native lands.

The ancient lineages recounted in the Gospels could do the ideological work of endorsing the agnatic system, since one son in each generation is singled out to continue the line from Adam to Christ (Luke 3:23–38) or from Abraham to Christ (Matthew 1:1–17). All but eight of the surviving Canterbury figures are listed in the Gospel of Luke, which names no women; Luke's list is supplemented by figures from the Gospel of Matthew, which counts fewer generations after David but includes the Virgin Mary as well as Joseph. None of the other four mothers in Matthew's genealogy—Tamar, mother of Phares; Rahab, mother of Booz; Ruth, mother of Obed; and Bathsheba, formerly wed to Uriah and mother of David's sons Solomon and Nathan—were represented in the glass program (see diagram, fig. 13). The habitual absence of these women from scholarly inquiry is a recent subject for feminist analysis.[3] When the Canterbury series was complete, the agnatic line from Adam to Christ allowed for only one woman, a virgin mother, the miraculous genetrix Mary. Matthew traced the precursors to Joseph, "husband of Mary," and Luke referred to Jesus as the son of Joseph "as was supposed." Both Gospels thus raised for medieval theologians the awkward question of physical paternity, but they eagerly pointed out that Mary also descended from the kings of Judea—giving Mary as well as Joseph a place in Canterbury's genealogy. Joseph's inclusion also endorsed the custom that legal paternity in the Middle Ages was generally extended to all children born in wedlock, unless the mother was charged with adultery. Suspicion of Mary was answered in the Gospel account by the miraculous appearance of an angel who told Joseph that Mary had conceived of the Holy Ghost (Matthew 1:18–25).

The Old Testament sources were far messier. The ancestors recounted by Luke and Matthew provide a skeleton on which to hang the history of *man*kind before and under Mosaic law, which can be filled out by seeking their names in the Old Testament. Among the many twelfth-century theologians who contributed to a historical reading of the Bible, one of the most influential is Peter Comestor (died ca. 1178), for his *Historia scholastica*. Written in Paris, it was certain to be known in Canterbury because it was dedicated to the archbishop of Sens, who had received Archbishop Thomas Becket into exile in the 1160s.[4] It was, however, the Anglo-Saxon "Cotton Aelfric" Hexateuch manuscript, which belonged to the rival Benedictine Abbey of Saint Augustine just beyond the town wall of Canterbury, that provided the glass painters at the Canterbury Cathedral's priory with visual models for some of the progenitors. The Cotton Aelfric was annotated extensively in Old English and Latin about the time the windows were made.[5] Narrative scenes and family groups of patriarchs with wives and offspring are embedded in the Genesis myth. The glass painters dramatized and historicized figures such as Enoch and Noah by borrowing active poses from their stories and the general idea of seated figures for the others (compare figs. 17 and 29 [*Enoch*], 35 and 36 [*Noah*]; see also figs. 28 and 29 [*Jared*]).

Elsewhere, too, a historical reading of the Bible had given rise to an interest in genealogy; *historia* in liturgical books of the time referred to Old Testament readings.[6] In fact, the intellectual pursuit of derivations and lineages, whether the etymology of words or the ancestry of rulers and of Christ, was of fundamental importance in medieval thinking.[7] Numbers in the Bible—such as the life span of Methuselah, the years a king reigned, the total years from the beginning of time— were also held to be significant. Several manuscripts of the commentary on the Apocalypse by Beatus of Liébana, as well as eight bibles and two chronicles, contain a genealogical pictogram known as the *Liber generationis* (book of ancestors), as in Matthew's text.[8] Assiduously included are all the known progeny of each patriarch, from their wives and concubines. The mid-eleventh-century Beatus manuscript made at Saint-Sever in the south of France names the biblical figures in medallions that are linked into extended families spreading over fourteen pages (fols. 5v–12r). Abraham, son of Thara, is represented about to sacrifice his son Isaac, born of his revered wife, Sarah, who is also given a portrait. Named in the medallions are all his male offspring from Hagar and Cetura and their main branches (fig. 49). In the upper left are the years that had elapsed before Abraham and the note that here the second age of man ends, as he begins the third. Peter of Poitiers later constructed a similar descending tree, more conveniently inscribed on a scroll (fig. 50), a format that could be hung up for teaching in the monastic or cathedral schools.[9]

Yet to the monks and clerics who helped design the Canterbury windows, used them for teaching novices, or even explained them to the laity, the story lines and chronologies of the Bible were only a beginning.[10] The Bible was the *sacra pagina* (holy page) for textual study that also considered the allegorical

Fig. 49 | *Abraham with Isaac, His Wife Sarah, and His Descendants through Hagar and Cetura,* from the Apocalypse manuscript known as the Beatus of Saint-Sever, Abbey of Saint-Sever, France, mid-eleventh century. 36.5 × 28 cm (14⅜ × 11 in.). Paris, Bibliothèque nationale de France, Ms. Lat. 8878, p. 8

Fig. 50 | *Adam and Eve to Abraham and His Descendants,* from the scroll Compendium Historiae Genealogia Christi; Peter of Poitiers, first half of the thirteenth century. Full scroll: 343 × 37 cm (135 × 14½ in.). Cambridge, MA, Harvard University, Houghton Library, Ms. Typ 216

relationships between one event and another, especially the fulfillment of Old Testament prophesies, and prefigurations, or types, in the Gospels and even in current events. On a spiritual level the moral import of events was weighed; higher still, theologians interpreting the text looked for signs indicating the Last Judgment, to come.[11] The Canterbury community had access to rich interpretive tools, which it used especially in the lower windows of the choir, where the New Testament events are surrounded by Old Testament prefigurations and symbolic scenes, with dense Latin verses.[12] These lower windows are often referred to as "theological." The monks freshly borrowed some themes from the French theologians, but they derived others from earlier sources, showing an interest in if not a preference for legacy.[13] It has recently been argued that the program of the lower windows deliberately recalled one destroyed in the fire of 1174, which might have been invented before 1109, in the time of Archbishop Anselm.[14]

Another Anglo-Saxon manuscript points to a spiritual understanding of Christ's ancestry. The tenth-century Gospels manuscript in Boulogne shows Saint Matthew poring over his book to write about David and Abraham, Isaac and Jacob, whose diminutive figures are seated before him (Matthew 1:1–2); all but David, who is crowned, have halos and carry the palms that traditionally connote

Fig. 51 | *Saint Matthew and Twenty-Eight Ancestors of Christ, from David and Abraham to Amon* (Matthew 1:1–10), from the Anglo-Saxon Gospels of Saint-Omer, tenth century. Bibliothèque municipale de Boulogne-sur-Mer, Ms. 11, fols. 10v, 11r

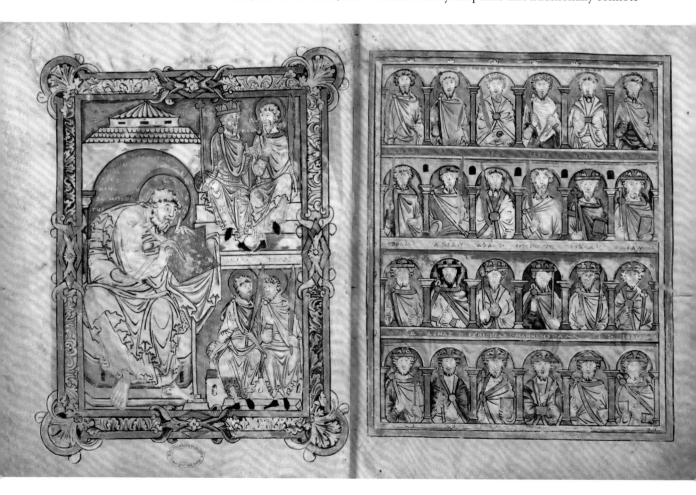

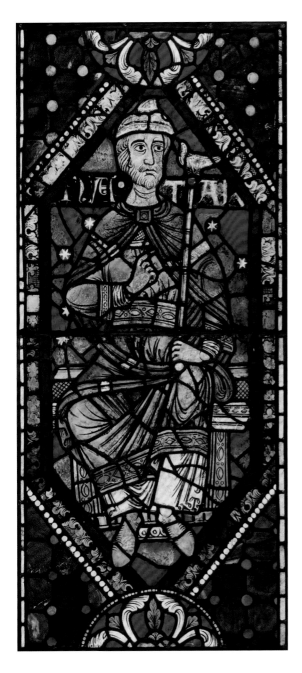

a place in heaven (fig. 51, left).[15] The series is expanded to forty ancestors on the next two pages, where the carefully labeled figures appear half-length in an arcade, as if making an appearance on the gallery of a palace; they are dignified by palms, or by scepters and crowns, and the rows of six break conveniently into the rhythm of threes in Matthew's verses 3–15 (fig. 51, right). They end on the third page with Jacob, father of Joseph (who is not represented); the lower half of the page has *The Annunciation to Mary* and *The Visitation of Mary and Elizabeth*, displacing Matthew's account of Joseph's suspicion of his wife and his dream. The visual elevation of the ancestors to the dignity of saints is significant for their later placement in the upper windows of a cathedral, where saints are normally seen.

As explained by Jeffrey Weaver in this publication, the Gospel genealogies might already have been the basis for the clerestory program of the choir that was partially destroyed in 1174. I have surmised that four panels of the Ancestors of Christ series made about 1150–60—*David*, *Nathan* (fig. 52), *Roboam* (see fig. 24), and *Abia*—had survived almost intact and that three of these were installed in the temporary wall that closed off the construction site to the east.[16] They called to mind the splendor of the past and embodied a pledge to reconstitute the series of which they were a part, despite the difficulty of adapting the cycle to a changed plan that involved more windows. To fill the additional windows, the designers supplemented Luke's list with names from Matthew's Gospel and digressed from the series of ancestors at midpoint to put *The Last Judgment* in the east window (see

Fig. 52 | *Nathan*, from the Ancestors of Christ Windows, Canterbury Cathedral, possibly third quarter of the twelfth century. Colored glass and vitreous paint, 120.6 × 70.5 cm (47½ × 24¾ in.), S. XXVIII, 12–13e

The head is a twentieth-century replacement, perhaps copied from the original.

fig. 14). Although Matthew's shorter list, tracing a line from Abraham, was often preferred in art, Saint Ambrose had characterized it as carnal descent, whereas Luke's list, ascending from Adam to God, was considered to signify spiritual ascent. The concept was further clarified in the most influential biblical commentary of the twelfth century, the Glossa Ordinaria: "Matthew begins by accounting for the descending generations, by which God descended to mankind through Christ's humanity; Luke references the ascending form of the sacrament. . . . He begins the genealogy with the son of God, and ends with the Son of God. He begins with creation in his likeness and ends with birth in his truth."[17]

Fig. 53 | *King Josias*, from the Jesse Tree Window in the Corona, Canterbury Cathedral, 1190s. Colored glass and vitreous paint, 76.2 × 83.7 cm (30 × 33 in.), n. III, 5

Josias and a similar panel of the Virgin are the only figures that have survived from this window. The good condition may in part be accounted for because they were protected from the elements in a private collection from the mid-nineteenth to the mid-twentieth century.

Giving these small figures a permanent place in Canterbury's Trinity Chapel (see fig. 9) involved surrounding the varied shapes of their panels with foliage reminiscent of Jesse trees, such as the one created for one of the windows in the eastern extension of the cathedral in the 1190s (fig. 53), in the contemporary portal sculpture at the Abbey of Braine in north France, and in the ceiling painting in the abbey of Saint Michel's Church in Hildesheim, Germany (fig. 54). In fact, an eccentric variant on the tree had been created in Canterbury about the time the first Ancestors of Christ series was devised for the windows: The rich figural program of the Eadwine Psalter, a magnificent cathedral priory psalter that celebrates a monk, Eadwine, as its scribe, was apparently once amplified by eight prefatory pages that illustrate the stories of Moses and David and of John the Baptist and Christ; a tree of Jesse inserted on the verso of the first folio from the Eadwine Psalter provides a transition from the Old Testament to the Gospels (fig. 55).[18] At the top, David promises the throne to Bathsheba's son Solomon

Fig. 54 | *Ancestors of Christ*, ceiling painting in the nave of Saint Michael's Church, Hildesheim, Germany, early thirteenth century

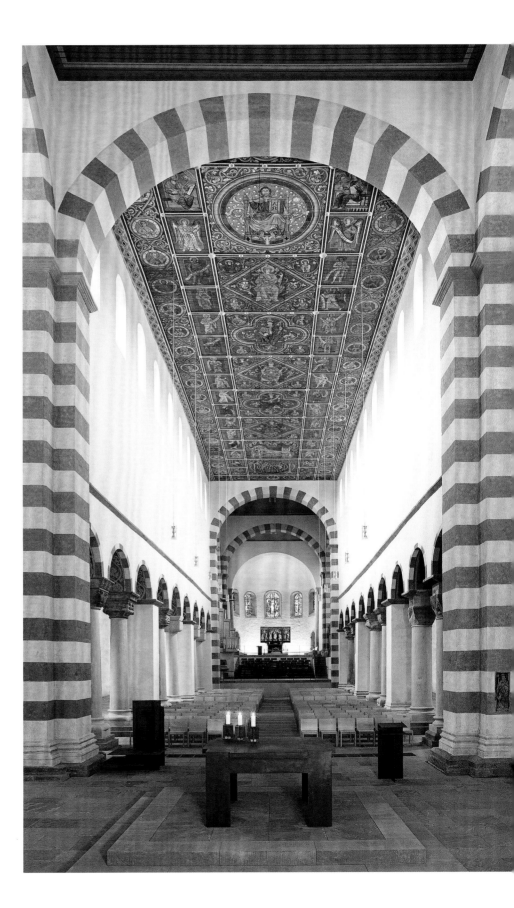

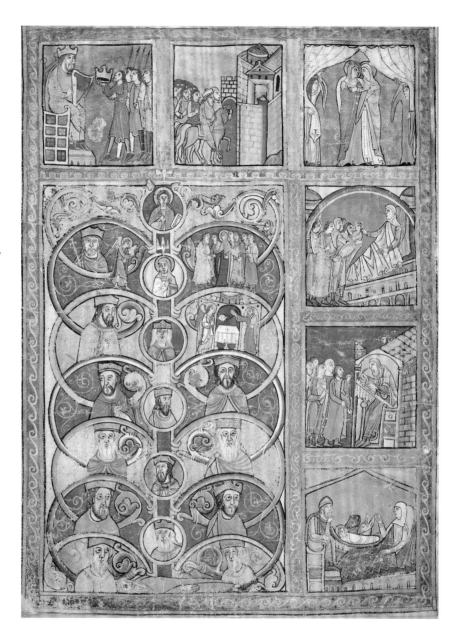

Fig. 55 | *Tree of Jesse and Scenes Illustrating Kings and the Gospel of Luke*, prefatory folio from the Eadwine Psalter, Canterbury Cathedral, ca. 1150–60. Ink, pigments, and gold on vellum, 40 × 29 cm (15¾ × 11⅜ in.). New York, The Morgan Library & Museum, MS M.724v. Purchased in 1927

(1 Kings 1:28–30), then Zadok the priest and Nathan the prophet (wearing a cap) take Solomon to his anointing (1 Kings 1:38), a subject that resonates with the figure of Nathan in the window (see fig. 52). Jesse is a prone cipher in the bottom of a rectangle with the tree. In front of the main stem busts of crowned kings float in four medallions, topped by two others, containing the Virgin and Christ. Ten more kings appear in lateral shoots. It is most unusual for imagery of the period that Luke's Gospel narrative weaves through the upper branches: to our right Zacharias censes the Temple altar, and an angel tells him that his wife, Elizabeth, will become pregnant with John the Baptist (Luke 1:11–20). The christological fulfillment is diagonally above, as the Virgin turns slightly toward the angel annunciate, and the dove of the Spirit (Luke 1:26–38) hovers over her head as well

as Christ's, as is normally depicted in Jesse trees. The marriage of the Virgin and Joseph (Luke 1:27) is cradled in the foliage at the top right. The Gospel sequence from Luke continues in four scenes in square frames to the right of the tree that read downward from the visitation of Mary and Elizabeth, through the birth and then naming of John, to the Nativity of Christ. The ensuing narrative depends on the Gospels of Luke, Matthew, and John and the Acts of the Apostles.

Another leaf, in the Morgan Library & Museum, New York, the institution that houses two of the folios from the Eadwine Psalter, more than doubles the number of scenes on each page. Overall, the eight scattered prefatory leaves are in at least two different styles, one of which has been described as derived from the St. Albans Psalter of circa 1130, attributed to the Alexis Master (see Weaver herein, p. 12), and the other from the "wet-fold" clinging drapery style of the famous Bury Saint Edmunds Bible or the slightly later prefatory pages from a Bury Saint Edmunds psalter.[19] Such diverse representational codes could have coexisted if the painters had been brought from far-flung artistic centers, as was the case with the documented stained glass of the Abbey of Saint-Denis of the early 1140s, for instance. Close study of the scribal hands in the Eadwine Psalter—including the principal one, which may belong to the monk Eadwine—in comparison with those of other manuscripts made for the Canterbury priory indicates that it was made between 1149 and 1163; on the assumption that the letter forms developed on a continuum, the mid-1150s is offered as a reasonable guess, although the closest comparison is with a work dated 1151.[20] The first half of the decade is still within the realm of possibility for the derivative figural styles.[21]

In its emphasis on kingship, and its anti-Jewish polemic, the Eadwine Psalter's tree of Jesse page (see fig. 55) contrasts sharply with the final form of the genealogy in the clerestory glass.[22] Despite the inclusion of David (a figure that may date in part from the earlier series), the extended ancestry in the windows avoided giving much importance to kings, as expected at the site where Archbishop Thomas Becket had been murdered in December 1170 owing to conflicts with King Henry II. Nathan, from Luke's list, was preferred over his brother Solomon, but Nathan did not rule; in the glass (see fig. 52) his Jewish cap and scepter identify him with the prophet of the same name who kept the scepter from Adonijah and reminded David to settle it on Solomon (1 Kings 1:11–45). Suspicion of kings, and a need for men of God to intervene with royal power, could antedate Becket in Canterbury, but it was reinforced by his martyrdom.

Despite their spiritual and political significance, it may seem surprising that Old Testament patriarchs—instead of Christian figures—were chosen for such a prominent place in the stained glass program. The answer has to lie with the Benedictine monastic community by and for whom the glazing was devised. Although their church also served as the *cathedra* (chair) of an archbishop (see Weaver herein, p. 17), he was increasingly absent through the twelfth century; in fact, he was building his own palace and chapel in London at the very time the

prior and monks were involved in the reconstruction of their choir. The monks of Canterbury had more spiritual considerations than inheritance and politics. In the European Middle Ages, family arrangements were complicated by a parallel system that removed a significant proportion of the population from heterosexual relationships and procreation, through the institution of monasticism and ultimately a celibate (unmarried) priesthood. Monks and nuns renounced their family names and titles, had no offspring, gave their inheritances to their churches, and created nonbiological families by calling the heads of their houses "Father" or "Mother," and their peers "Brother" or "Sister." One implication of this practice was that any sexual relationship within the monastery would be considered incestuous as well as homosexual. The most important task that the Benedictine community of the Canterbury priory and cathedral performed together in the church was the liturgy, comprising the hours of prayer, readings, and song that they knew as the work of God (*opus dei*). The clerestory program accorded with the liturgy for Christmastime: The genealogy of Matthew was sung at the end of Matins and before the Mass on Christmas Day; that of Luke, at Matins on Epiphany (January 6, or Twelfth Night), or on the octave (January 13) if monastic custom prevailed.[23] A northern European liturgical tradition going back to at least the ninth century involved special vestments and ceremonies and embellished the texts musically. Jeremy Noble has concluded, "In a feudal and aristocratic age the genealogies of Christ had taken on, in a more or less spiritual way, something of the character of a heraldic proclamation of titles, and [. . .] it was this which led them to be treated with special solemnity."[24] If the sung texts had been chanted without embellishment, the cadence of the verses and the rhythmic repetition of "qui fuit" (who was [the son] of) or "et autem genuit" (and he begat) would have been as somniferous as the "ora pro nobis" (pray for us) repeated after every saint's name in the litany. But even if the brethren glanced at the windows during the recitation—craning their necks from the stalls that faced the center of the choir to see figures far above, behind, to the east, and in front of them—the light would scarcely have been sufficient to show more than silhouettes and white name bands. Instead of having only a momentary cyclical significance once a year, the series of figures recounted history throughout the year, laying out its sequence to be recalled and explored at other times, in the context of the other windows.

When the monks processed into their choir, they could see at least ten figures from the beginning and end of the program, including the magnificent personages on the north side, where the surviving *Adam, Methuselah, Enoch, Jared,* and *Lamech* were situated (see plan, fig. 13; and figs. 12, 16, 17, 28, and 31). Opposite the *Creator* was *Christ*. God created Adam in the dim light of the north side and brought Jesus shining into the world through the Virgin Mary opposite, in the south; as Saint Paul wrote: "And as in Adam all die, so also in Christ shall all be made alive" (1 Cor. 15:22). Entering the eastern transepts and presbytery from their cloister, the monks would see other Ancestors of Christ figures. Additionally, the

Fig. 56 | *Moses and Synagogue*, from the North Oculus, Canterbury Cathedral, ca. 1178–80. Colored glass and vitreous paint, 89 × 95 cm (35 × 37⅜ in.), N. XVII, O, 1

Moses, who was believed in the Middle Ages to be the author of the first five books of the Old Testament, holds a book and points to the tablets of the law that he had received on Mount Sinai, here held by a female personification of Synagogue. Large oculi (round windows) in the end walls of the east transepts punctuated the Ancestors of Christ series. The panel is surrounded by prophets and virtues (not shown). Both heads and the left two-thirds of the inscription are early-twentieth-century replacements by the Canterbury restorer Samuel Caldwell Sr.

unusually large, round oculi of the transept ends ensured a prominent position on the north to Moses, holding a book (he was not an ancestor of Christ), paired with Synagogue, who holds the tablets of the law (fig. 56); we can assume that Christ with his Church faced them on the south.[25] Moses resonated with his figure in several of the theological windows, as in the second of the choir aisle, where he leads the Hebrews out of Egypt—a scene that demonizes a king (see fig. 30).[26] The immediate message is that the event is an allegory of salvation, of Christ leading his followers. Lessons were pertinent for the moment too: the scene would have recalled Thomas Becket taking his supporters into exile in France to escape the wrath of Henry II, and it would have encouraged the cathedral monks to take the same route in 1207 to escape King John.[27] Moses appears five times in the east window: before the burning bush, consecrating Aaron, receiving the law, with Jethro (see fig. 32),[28] and striking the rock to bring water just as the spear brings salvific blood from Christ's side in the next frame. The latter scene is thus associated with Becket, who was known as the lamb of Canterbury because his martyr's blood was used as a cure.[29] Such interweaving occurred for a number of the clerestory figures, so that they accrued meanings by intervisuality: Adam, with his hoe as in the clerestory (see fig. 12), Noah with his ark, Abraham with a sword and flame, David with a harp, Jechonias with a crown and scepter, and Christ mark the ages of this world, symbols of the six jars of water turned to wine in Christ's first

81

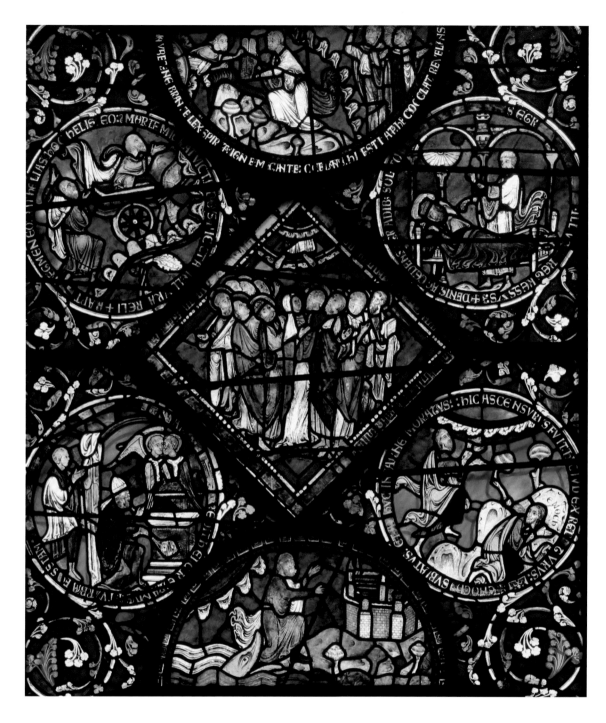

miracle (see fig. 47). Noah in the clerestory reaches out like his counterpart in the ark (see figs. 35 and 37, respectively), another figure of salvation and precursor of Christ. Noah's son Shem rules the world with his brothers, under the eye of the Holy Church; they are precursors, or types, of the Trinity (see fig. 41). King Jeroboam is privileged by a warning from God to be on his way, just as the Magi were. Enoch, turning and looking upward as the hand of God grasps his wrist (see figs. 17, 48), resonates with the narrative panel in the latest of the theological

Fig. 57 | *Enoch Taken up to Heaven*, (lower right rondel), detail from the Redemption Window in the Corona, Canterbury Cathedral, before 1207. Colored glass and vitreous paint, diam: 51 cm (20 1/16 in.), e. I, 34

Enoch appears twice, praying on the hillside (his name is beside him) and being lifted up by the hand of God. This is a type of the Ascension of Christ, which is depicted in the central panel of the window. Both Enoch heads have been replaced.

windows, the redemption in the east, where he is forewarned and then ascends (fig. 57); he takes his place there alongside the ascending Christ, as a type rather than an ancestor. Above the rondel with Enoch is one with King Ezekias, whose dream of the sun's shadow reversing itself also foretold the Ascension; in the clerestory, he holds the sundial (see fig. 23). Abraham prepares to sacrifice Isaac at the command of God in the same window, above the Son of God on the Cross. And in an adjacent window with a tree of Jesse, perhaps the gift of the Queen Mother, Eleanor of Aquitaine, the ancestral kings are celebrated, no doubt this time including Solomon; Josias is the only one to survive, with the Virgin (see fig. 53).[30] The complexity of the relationships between the subjects depicted, which made it necessary for medieval viewers to study manuscript copies of the inscriptions, was anchored in the immutable chronological sequence of the patriarchs in the upper windows, and they in turn could trigger memory of the *sacra pagina*. Yet the knot that pulls the whole program together is in the east windows at both levels: in the Corona the Crucifixion, Resurrection, and Ascension of Christ (with Old Testament prefigurations) read upward; from the high altar in the choir the Last Judgment would have been seen above, bringing an end to time with Christ's Second Coming, to judge mankind, as predicted in Matthew 25:31–34 (see fig. 14).[31]

Modern historians tend to define cultures by their written records, privileging texts in the construction of history. Because we know what ecclesiastics were reading and writing when they created the stained glass program, it is possible to gauge its visual and intellectual impact on the immediate community; it is far harder to surmise its affective power over a wider public. Yet the monumental arts were accessible in a way that manuscript illumination and precious objects like reliquaries were not, and one can assume that the windows had a dramatic effect. That Canterbury was a priory church, a cathedral, and a pilgrim church meant its doors were open not only to churchmen from elsewhere but also to rich and poor among the laity. In light of that, it is notable that the church never had around its public entryways any exterior sculpture of the kind so richly developed in France and Spain and later at Wells and Salisbury. Everything at Canterbury was instead carried to the interior, like a great shrine with its decoration on the inside; indeed, after 1220 the Trinity Chapel and Corona became shrines of Thomas Becket.[32] Before that, pilgrims hoping for a cure by being near Becket's relics, or imbibing his blood, had to descend into the crypt. But to reach the area where his new shrine was placed, they climbed the steps on either side of the choir, thus passing under the luminous theological windows, which at the least created an atmosphere of rich color and dense ornament. Perhaps a guide would have translated the verses inscribed under the first window on the north side, which explained that light passing through glass without breaking it is a sign of the miraculous conception and birth by which Christ (who is the way, the truth, and the life; John 14:6) entered the world.[33] A glance at the clerestory would confirm the authority of the church—in the secular world, such seated

figures appeared on the seals of bishops and kings.[34] Displaying Christ's long line of ancestors did the ideological work of reaffirming customary inheritance practices and the rights of temporal lords.[35]

One group of Canterbury citizens that is generally overlooked in scholarship on this church's history is the local Jewish community, which had a good relationship with the cathedral priory throughout the twelfth century.[36] Becket's learned secretary, Herbert of Bosham, studied Hebrew to better understand scripture.[37] It is notable that *Josias*, originally in clerestory window N. V (see fig. 13), has a scroll with a pseudo-Hebrew inscription. In fact, a Jewish scribe named Robert, who was among those who rented property from the priory, was one of the official "chirographers" for the town, whose task was to see that copies of debtors bonds were kept in the king's chest; these documents would have been written in Hebrew. Jacob the Jew was a sitting tenant on High Street and built a large stone house on three lots. Next to him was the synagogue, also built on ground that belonged to the cathedral priory, with rent paid to the priory through a citizen. Mutual dependence was established in 1189, when the monks were confined to their house by the archbishop, and Jews were among the townsfolk who passed food to them through the wall and also prayed for them in the synagogue, according to the monastic chronicler Gervase. It is likely that the cathedral building rising out of the ruins in the 1180s and 1190s seemed welcoming to any Jewish townspeople who were curious to see it. They would recognize *Nathan* (see fig. 52) and many others with their prophet's caps and look up at the elegant figure of Synagogue with the tablets of the law, who is not blindfolded as was customary in Christian art; Moses even has the halo usually given to saints (see fig. 56). In 1218–19, when the Trinity Chapel was being perfected for the translation of Becket's relics to the new shrine, Jews made loans to help with the cost of building. The thirteenth-century monastic chronicler Matthew Paris may have told a half-truth when he wrote, "Aaron the Jew, who held our debts, coming to the house of St. Alban in great pride and boastfulness, claimed that he had made the shrine of our Saint Alban with his own money"; always anti-Jewish, Matthew was probably suppressing any knowledge he had of Aaron's genuine interest in the decorations of the building.[38] At Canterbury the windows in the highest position recount a common past, differing only in the act of Christian faith that affirmed Jesus as the Messiah. When Archbishop Stephen Langton issued a synod in 1222 forbidding Jews to enter churches or to buy food from Christians, and to enforce the requirement of the Lateran Council of 1215 that they wear a mark of difference in their dress (in this case two white stripes on their outer garments), it was probably resisted by the monks.[39] Even during the next fifty years, as their royal protectors gradually stripped the Jewish community of its wealth and livelihood, eventually expelling all Jews from England in 1290, the monks of the cathedral priory continued to sell town property to Jews, with full hereditary rights in perpetuity, despite a decree against it.[40]

Fig. 58 | *Patriarchs and Archbishops of Reims*, three retrochoir clerestory windows, Abbey Church of Saint-Remi, Reims, France, ca. 1180

There were frequent contacts between Canterbury and the Benedictine Abbey of Saint-Remi in the twelfth century, and it appears that the stained glass atelier that provided this glass went on to work briefly in Canterbury and thereafter in Braine, France.

The contemporary Benedictine Abbey Church of Saint-Remi in Reims, France, situated outside the town walls yet intimately connected to the coronation cathedral within, offers an example of a clerestory program with quite a different focus from Canterbury's. Although seated Old Testament patriarchs occupy the upper half of each lancet in the straight bays of Saint-Remi's retrochoir, they are paired with enthroned archbishops of Reims (fig. 58).[41] These static figures are precursors not of Christ but rather of Christian churchmen, and in the turning bays at the east end they are replaced by the apostles, who encircle the Virgin. Also in Saint-Remi a few smaller standing figures survive from a series of ancestors; they may have occupied a position in the nave galleries. The Abbey of Saint-Remi was like Saint Augustine's Abbey in Canterbury in that it laid claim to all the early burials of the archbishops, but in its royal connections the Abbey of Saint-Remi rivaled the coronation cathedral within the city of Reims. Enthroned kings of France were placed in the nave clerestory, to be seen when the future king arrived to pay homage for the holy oil that was to consecrate him. Canterbury Cathedral, on the other hand, seems not to have developed a program for royal processions until the west window of the nave was filled with kings of England, about 1390.[42]

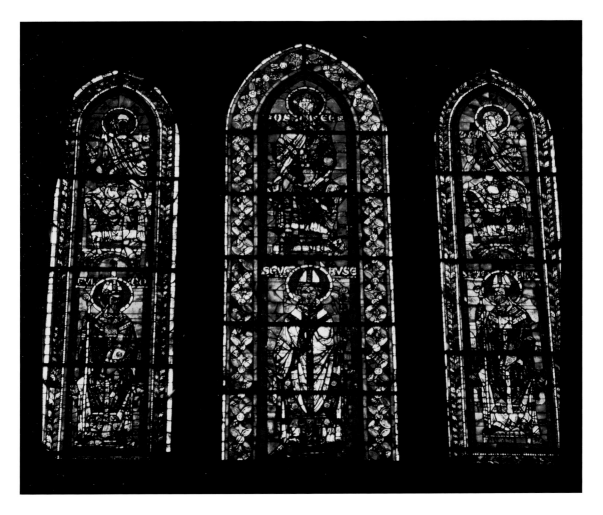

A Benedictine program that lays much greater store on Christ's royal ancestry than either Canterbury or Saint-Remi is the ceiling painting in Saint Michael's Church, Hildesheim (see fig. 54). It stretches the full length of the nave, nearly eighty-eight feet (25.5 m), between eastern and western choirs.[43] Although the margins contain sixty-four busts encircled by their names and "qui fuit" from Luke's genealogy, beginning under the large figures of Adam in the center, four monumental kings stemming from Jesse dominate the composition, and each has four small busts of kings imbedded in the foliage surrounding him.[44] Toward the east end is the Virgin, bringing the total number of ancestors to eighty-four—the seventy-seven from Luke supplemented by seven kings presumably from Matthew. Numerically, the program nearly matches Canterbury's genealogical windows, but the composition gives overwhelming importance to the line of Judea. The ceiling was originally painted during the second quarter of the thirteenth century.[45] It followed a period of restoration and embellishment that began in the 1180s and concentrated on the monks' choir in the west end of the church following the canonization of the founder, Saint Bernward, and the translation of his relics to a shrine in the upper church in 1194.[46] The last phase of decoration created a brilliantly colored processional way for the monks as they moved from their western choir to the eastern apse—a path they could have followed at the end of Matins on Christmas and Epiphany.[47] The ceiling in this small, essentially Ottonian building is only fifty-two and a half feet (16m) from the floor, and it is well lit from windows placed high in the walls under it. It was easily visible, and more accessible than the Canterbury program, to lay pilgrims, for whom the Jesse tree would have resonated with images in single stained glass windows elsewhere, in the painted vaults of the so-called Brunswick Cathedral (the former collegiate church of Saints Blaise and John the Baptist in Braunschweig, Germany), or even in their own prayer books.[48] It was created during the reign of the great Hohenstaufen emperor Frederick II, who ruled all of Germany and much of Italy, during a time of relative accord between the emperor and ecclesiastics.

Before characterizing the Canterbury program as monastic and patriarchal, we have to consider that it was imitated by a female lay patron in her Premonstratensian foundation at Braine in northern France.[49] For Agnes, countess of Braine, and her descendants, the ancestors of Christ arranged two by two just as at Canterbury presided over the pantheon of a cadet Capetian line: As heiress to the duchy of Braine, Agnes had married King Louis VII's brother Robert of Dreux. After her death in 1204, the genetrix was entombed at the head of the church, behind the altar where shrines were usually placed. The glass painters had strong connections with Saint-Remi and Canterbury—as Agnes had with English and French royalty; *Aminadab* from Braine (fig. 59), one of the figures salvaged during the French Revolution and installed in Soissons Cathedral, and *Naasson* at Canterbury (see fig. 22) are among the figures based on cartoons previously used in Saint-Remi.[50] None of the surviving figures indicate that the painters at Braine adapted the Can-

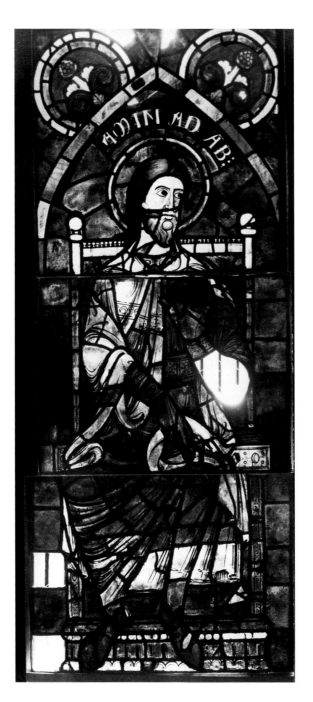

Fig. 59 | *Aminadab*, from an ancestor of Christ clerestory window, Abbey Church of Saint-Mary and Saint-Yved, Braine, France, ca. 1195–1204. Colored glass and vitreous paint, 180 × 80 cm (70¾ × 31½ in.). Photographed about 1920. Now in the apse clerestory, Soissons Cathedral, France, window 103

The glass in Soissons was damaged during World War I and repaired afterward, but since then the atmosphere has turned it almost black, so the figure can be seen well only in an old photograph.

terbury formula to slant the program toward female ancestors or saints, although the sculptors did include a Sybil in the Jesse tree that surrounds *The Dormition of the Virgin Mary* in the west portal. Perhaps Agnes had been aware that the rights of women to rule their lands were being challenged and that the future belonged to the sons and grandsons who would be buried near her. At least one other royal woman of her generation also embraced extended genealogical series.

It has long been recognized that a lavish cycle of paintings on the diaphragm arches of the chapter house for the Order of Saint John of Jerusalem in Sigena, a

remote site in northern Spain, included at least seventy ancestors, like Canterbury's based on both Gospels: forty-two (or perhaps originally forty-eight) from Luke on three arches, and twenty-eight (or thirty-two) with the "et autem genuit" phrase from Matthew on the two easternmost arches (fig. 60), adjacent to the Nativity.[51] They resonate with Old Testament narrative scenes on the spandrels, such as Adam and Eve working after the fall (fig. 61). The program culminates on the east wall with the motherhood of the Virgin.[52] This house for nuns of the Knights Hospitallers' order was founded in 1184 by Sancha of Léon-Castille, wife of Alphonso II of Aragon (died 1196), as a pantheon for the new dynasty that united Aragon and Catalonia. A preexisting chapel may have served the nuns while the chapter house and monastic buildings were in construction, but the new church was completed by 1196, when the widowed queen became a nun. The chapter house was probably finished by 1187/88, or 1191 at the latest, and its decoration was surely also completed well before the queen's death in 1208, when she was buried in the apse of the church.[53] The principal painter of the chapter house had worked on the famous Bible made for Winchester Cathedral, and his style also had

Fig. 60 | *David and His Son Solomon* and *Solomon and His Son Roboam*, wall painting from a soffit of the chapter house, Royal Monastery of Saint Mary of Sigena; Aragon, Spain, early 1190s. Photographed before fire damage in 1936. Now in the Museu Nacional d'Art de Catalunya, Barcelona

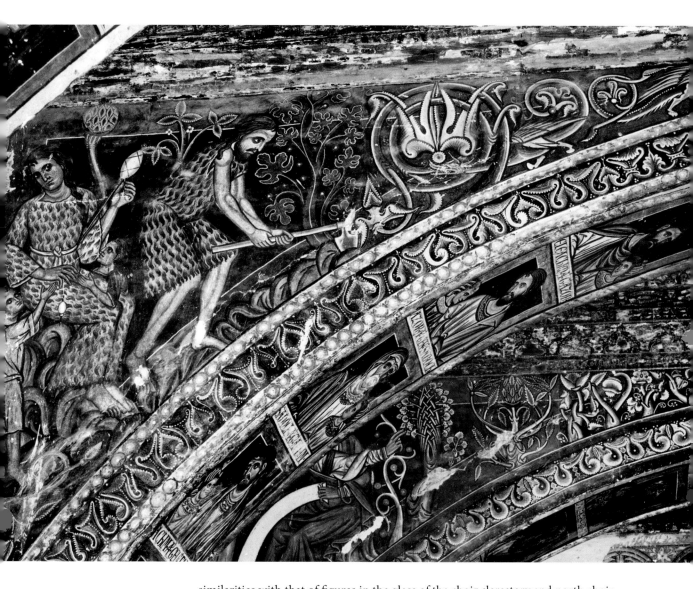

Fig. 61 | *Adam and Eve Working* and *Eliakim, Azor, Sadoc, and Achim with Their Sons,* wall paintings from a spandrel and soffit of the chapter house, Royal Monastery of Saint Mary of Sigena; Aragon, Spain, early 1190s. Photographed before fire damage in 1936. Now in the Museu Nacional d'Art de Catalunya, Barcelona

similarities with that of figures in the glass of the choir clerestory and north choir aisle in Canterbury—such as *Adam* and *The Exodus* (see figs. 12, 30)—and with the Great Canterbury Psalter, now in Paris, of about 1180–1200.[54] From his knowledge of the Canterbury genealogical program, this painter may have proposed a similar subject for Sigena. The liturgy of the Hospitallers likewise had embellishments for the recitation of Matthew's genealogy at Christmas.[55] Chapter houses had a variety of administrative and ritual functions, including some services.[56] Karl Schuler has commented that Queen Sancha did not ask for a particular emphasis on kingship in the selection of ancestors—there are only two—but the first inmates were drawn from the upper nobility and were evidently chosen with a concern for physical lineage; according to a supplementary rule, a nun could be banished for a year for calling another a bastard if she had no proof![57] Yet the issue for the chapter house program was surely to form a community of lineage that also had spiritual links to Christ and his mother.

89

Fig. 62 | *Nine Ancestors of Christ, Abraham to Aminadab* (Matthew 1:2–4) and *Isaac's Wife, Rebecca, Inquiring of the Lord* (Genesis 25:22–23), from the Pamplona Bible; Spanish, 1194–97. Amiens, France, Bibliothèque municipale Ms. lat. 108, fol. 15r

Fig. 63 | *King David and His Child Solomon* and *King Solomon and His Child Rehoboam* (Roboam), from the Pamplona Bible; Spanish, 1194–97. Amiens, France, Bibliothèque municipale Ms. lat. 108, fol. 159r

Related programs are in a Bible picture-book made about 1194–97 in Pamplona for King Sancho VII, "le Fuerte," of Navarra, which is much less artistically accomplished. The genealogy is first encountered in Genesis chapter 25, illustrated by busts in medallions denoting Abraham's line down to Jesse, and by the angel of the Lord telling Rebecca that her womb holds two nations—the twins Jacob and Esau (fig. 62); the example is interesting for agnatic inheritance because it is one in which the birthrights of the firstborn were challenged by his brother and would likely be elucidated by the king's tutor or confessor.[58] More imposing are the seated fathers, for the most part kings, interacting with their small sons, who illustrate Matthew's genealogy from David to Joseph; they extend through fifteen pages (fig. 63). The series is placed at the end of the Old Testament, as if to emphasize its historicity. François Bucher has commented on concerns about consanguinity, since it was all too common in European royal circles to defy the Church's injunction against marrying a cousin. Another factor in the prominence given to the theme of ancestry would be the influence of the illuminated Beatus manuscripts in Spain (see fig. 49). When King Sancho's Bible was immediately copied for a woman, the series was expanded back to Abraham, filling nineteen pages (fols. 177r–186r).[59] The recipient is not known, but Bucher proposed either Sancho's Muslim wife, Baezo, or Queen Sancha of Aragon, the patron of Sigena.[60]

Fig. 64 | *Ancestors of Christ from Salmon to Solomon* (Matthew 1:5), from the Glajor Gospels; Armenian, 1300–1307. Los Angeles, UCLA, University Research Library, Special Collections, Arm. Ms. 1, p. 30

I close with some geographically distant examples of fascination with the genealogies of Christ, in deluxe Armenian Gospels of the thirteenth and four-teenth centuries. Most famous is the Glajor Gospels manuscript of 1300–1307, now in Los Angeles (fig. 64).[61] This is the only cycle in any manuscript that equals the one in Queen Baezo/Sancha's Bible, spreading enthroned figures from Matthew's complete genealogy of patriarchs or kings at a leisurely pace over eight pages. All the figures mentioned in the Old Testament as kings have elaborate crowns; the other ancestors have halos. The Gospels were made for the contemplation of a priest, to whom the specifically Syrio-Armenian notion of inherited priesthood would be familiar. The cycle begins and ends with Christ enthroned and blessing, emphasizing his legacy as priest, prophet, and king.

An earlier Armenian Gospels manuscript, now in Baltimore, brings me back to the comment made at the outset about the exclusion of the mothers named by Matthew from Western representations (fig. 65). This manuscript was commissioned by the priest T'oros, nephew of the catholicos Constantine I, and illuminated by T'oros Roslin, one of the most important illuminators of Armenian manuscripts. In 1266 the priest presented the manuscript, completed in 1262, to the hermitage of Ark'akaghin in Cilicia so that masses would be said for his soul.[62] A single page has twenty patriarchs selected from Matthew's genealogy. In the table below I have numbered them according to his sequence and clarified which have their consort on their left (our right):

1 Abraham	6 Esrom	14 David and consort →Bathsheba	
2 Isaac	7 Aram	15 Solomon	22 Jotham
3 Jacob	8 Aminadab	16 Roboam	23 Ahaz
4 Juda and consort →Tamar		21 Uzziah (Josias)	24 Ezekias
10 Salmon and consort →Rahab		25 Manasseh	26 Amon
11 Booz and consort →Ruth		27 Josias	28 Jechonias

It becomes evident that the presence of women is quite disruptive to patriliny, preventing an easy sequence of patriarchs and displacing some—even including Jesse, father of David![63] The Armenian illuminations have no close Western connections, which brings us back to the idea that genealogies have ever been of great human interest, not only for Christian readers of the Bible but also in the Arabic tradition.[64] Currently, almost every day, I receive an e-mail telling me that yet more people I have never heard of have been added to my family tree in cyberspace.

Fig. 65 | *Ancestors of Christ from Abraham to Jechonias, Including Thamar, Rahab, Ruth, and Bathsheba* (Matthew 1:2–11), from the Gospels by T'oros Roslin; Armenian, 1262. Ink, paint, and gold on parchment, 30 × 21.5 cm (11¹³/₁₆ × 8⁷/₁₆ in.). Baltimore, Walters Art Museum, Ms. W. 539, fol. 15r

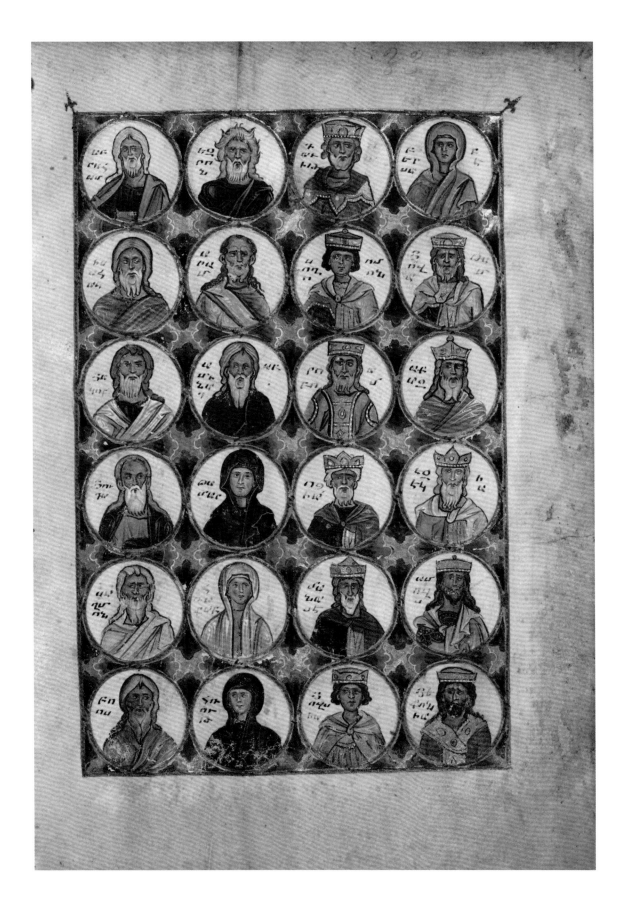

NOTES

I am grateful to Emily Monty for her research and technical assistance; to Léonie Seliger and the staff of the Canterbury Cathedral Studios for access to some of the stained glass; to Sandy Heslop for reading a draft; to Barbara Haagh-Huglo for liturgical information; to Christina Maranci for insight concerning Armenian manuscripts; to Eva Hoffman for help with Arabic genealogies; and to Jeffrey Weaver, whose collaboration I have enjoyed immensely during the preparation of our essays.

1. The phrase is that of Christiane Klapisch-Zuber, "The Genesis of the Family Tree," *I Tatti Studies: Essays in the Renaissance* 4 (1991): 122. Klapisch-Zuber offers a highly useful survey of genealogical representations.

2. See the Introduction to Mary Jo Maynes et al., eds., *Gender, Kinship, Power: A Comparative and Interdisciplinary History* (New York: Routledge, 1996), 1–23.

3. Ann Belford Ulanov, *The Female Ancestors of Christ* (Boston: Shambhala, 1993), 1–6. She notes the significance of family trees in psychoanalytic object relations theory. Jane Schaberg, *The Illegitimacy of Jesus: A Feminist Theological Interpretation of the Infancy Narratives*, Biblical Seminar 28 (Sheffield, UK: Sheffield Academic Press, 1995), 20–34. See also Helen Bruch Pearson, *Mother Roots: The Female Ancestors of Jesus* (Nashville, TN: Upper Room Books, 2002).

4. Lesley Smith, *The Glossa Ordinaria: The Making of a Medieval Bible Commentary*, Commentaria 3 (Leiden: Brill, 2009), 154, 209–11.

5. Madeline H. Caviness, *The Early Stained Glass of Canterbury Cathedral, Circa 1175–1220* (Princeton, NJ: Princeton University Press, 1977), 111–15, figs. 7, 11, 15, 16, 17. A thorough recent study of the annotations has identified the sources in Saint Augustine's library but overlooks the visual links with the Canterbury Cathedral glass: A. N. Doane and William P. Stoneman, *Purloined Letters: The Twelfth-Century Reception of the Anglo-Saxon Illustrated Hexateuch (British Library, Cotton Claudius B. IV)*, Medieval and Renaissance Texts and Studies 395 (Tempe: Arizona Center for Medieval and Renaissance Studies, 2011). Their findings are summarized in pp. 1–12, and Normannus, one of the commentators, is identified as a monk of Saint Augustine's, pp. 339–60.

6. Andrew Hughes, *Medieval Manuscripts for Mass and Office: A Guide to Their Organization and Terminology* (Toronto: University of Toronto Press, 1995), 22.

7. R. Howard Bloch, *Etymologies and Genealogies: A Literary Anthropology of the French Middle Ages* (Chicago: University of Chicago Press, 1983); Christiane Klapisch-Zuber, *L'ombre des ancêtres: Essai sur l'Imaginaire médiéval de la Parenté*, Esprit de la Cité (Paris: Fayard, 2000).

8. Yolanta Załuska, "Le Beatus de Saint-Sever à travers sa composition matérielle et ses généalogies bibliques," in *Saint-Sever, Millénaire de l'Abbaye: Colloque international, 25, 26 et 27 Mai 1985*, ed. Jean Cabanot (Mont-de-Marsan, France: Comité d'études sur l'histoire et l'art de la Gascogne, 1986), 279–92. See Beatus of Liébana and Saint Jerome, *Comentarios al Apocalipsis y al Libro de Daniel: Edición facsímil del Códice de la Abadía de Saint-Sever Conservado en la Biblioteca nacional de Paris bajo la signatura Ms. Lat. 8878 / Commentaires sur l'Apocalypse et le Livre de Daniel: Édition en fac-similé du manuscrit de l'Abbaye de Saint-Sever conservé à la Bibliothèque nationale de Paris sous la cote Ms. Lat. 8878*, Serie Códices Artísticos 7 (Madrid: Edilán, 1984), fols. 5v–12r.

9. Philip Samuel Moore, *The Works of Peter of Poitiers, Master in Theology and Chancellor of Paris (1193–1205)* (Washington, DC: Catholic University of America, 1936), 1–6, 97–117. Peter succeeded Peter Comestor in Paris in 1169 and served as chancellor from 1193 to 1205.

10. Madeline H. Caviness, " 'The Simple Perception of Matter' and the Representation of Narrative, ca. 1180–1280," *Gesta* 30 (1991): 48–64. Reprinted in Caviness, *Art in the Medieval West and Its Audience*, Variorum Collected Studies 718 (Aldershot, UK: Ashgate, 2001), chapter 3.

11. Madeline H. Caviness, "Images of Divine Order and the Third Mode of Seeing," *Gesta* 22 (1983): 99–120. Reprinted in Caviness, *Art in the Medieval West*, chapter 2.

12. More than one hundred glossed volumes, many of them gifts of Becket, were in the library of Christ Church (Smith, *Glossa Ordinaria*, 164–65).

13. Several of Aelfric's writings were used, as cited by Richard William Pfaff, "Some Anglo-Saxon Sources for the 'Theological Windows' at Canterbury Cathedral," *Mediaevalia* 10 (1984): 49–62.

14. T. A. Heslop, "St Anselm, Church Reform, and the Politics of Art," *Anglo-Norman Studies* 33 (2011): 103–26.

15. Thomas H. Ohlgren, comp. and ed., *Anglo-Saxon Textual Illustration: Photographs of Sixteen Manuscripts with Descrip-*

tions and Index (Kalamazoo: Medieval Institute Publications, Western Michigan University, 1992), 54–55; fol. 11v is reproduced in pl. 322.

16. Madeline H. Caviness, "Romanesque 'belles verrières' in Canterbury?," in *Romanesque and Gothic: Essays for George Zarnecki*, ed. Neil Stratford (Woodbridge, UK: Boydell Press, 1987), 35–38, reprinted in Caviness, *Paintings on Glass: Studies in Romanesque and Gothic Monumental Art*, Variorum Collected Studies 573 (Aldershot, UK: Ashgate, 1997), chapter 4. See also Caviness, T*he Windows of Christ Church Cathedral, Canterbury*, Corpus Vitrearum Medii Aevi (CVMA), Great Britain 2 (London: Oxford University Press for the British Academy, 1981), 41–44, figs. 68–69, 72–73. Readers are cautioned to examine the CVMA restoration charts, which are always included in the figures.

17. Eleanor Simmons Greenhill, *Die geistigen Voraussetzungen der Bilderreihe des Speculum Virginum: Versuch einer Deutung*, Beiträge zur Geschichte der Philosophie und Theologie des Mittelalters: Texte und Untersuchungen 39, no. 2 (Münster, Germany: Aschendorff, 1962), 50–51, citing Saint Ambrose, *Expositio Evangelii Secundum Lucam*, Centre Traditio Litterarum, Occidentalium 14 (Turnhout, Belgium: Brepols, 2010), 100, 106. The Glossa Ordinaria on Matthew 1:2 (*Patrologia Latina*, 144, 65D) states: *Matthaeus generationem descendendo incipit vel computat: quia humanitatem Christi ostendit, per quam Deus ad homines descendit. Lucas ascendendo referens formam sacramenti aperit. . . . A Filio Dei generatio incpit, terminatur in Filium Dei, precedit creatus in figura, ut sequatur natus in veritate.* (Translation in essay is mine.)

18. C. M. Kauffmann, *Romanesque Manuscripts, 1066–1190*, ed. J. J. G. Alexander, A Survey of Manuscripts Illuminated in the British Isles (London: Harvey Miller, 1975), 93–97, figs. 173–87, cat. no. 66, listing all the subjects; Margaret Gibson, T. A. Heslop, and Richard W. Pfaff, eds., *The Eadwine Psalter: Text, Image, and Monastic Culture in Twelfth-Century Canterbury*, Modern Humanities Research Association 14 (London: Pennsylvania State University Press, 1992), 29–42.

19. The manuscript in the Morgan Library is MS 521. The styles are discussed by Kauffmann, *Romanesque Manuscripts*, 95, who dates the Eadwine leaves to circa 1140 based on such comparisons. Gibson et al., *Eadwine Psalter*, 25–34, accepts earlier views, associating one style with St. Albans and the other with the Lambeth Bible of circa 1140–50 from Saint Augustine's Abbey, Canterbury; his discussion of iconographic sources allows for models that were available before circa 1160.

20. Teresa Webber, "The Script," in Gibson et al., *Eadwine Psalter*, 22–24 (cf. Margaret Gibson, "Conclusions," 210, who leaps forward to ca. 1160).

21. I do not find it necessary to invoke the style of the Lambeth Bible. Kauffmann, *Romanesque Manuscripts*, 103–4, figs. 208 and 209, cat. no. 75, offers a comparable blend of "St. Albans" figure types and "Bury" wet-fold drapery in a manuscript that he dates to ca. 1150.

22. George Henderson discusses the textual sources of the leaves in Gibson et al., *Eadwine Psalter*, 35–42; he points out that the Moses cycle on the recto of the Morgan leaf emphasizes Jewish faithlessness and the failed rule of Saul (35–36).

23. Hughes, *Manuscripts for Mass and Office*, 62, 212 (see p. 3 for the octave).

24. Frank Ll. Harrison, *Music in Medieval Britain*, 4th ed. (Buren, Netherlands: Knuf, 1980), 71–72; Jeremy Noble, "The Genealogies of Christ and Their Musical Settings," in *Essays on Music and Culture in Honor of Herbert Kellman*, Collection "Epitome Musical" 8, ed. Barbara Haggh (Paris: Minerve, 2001), 197–208, esp. 198.

25. Caviness, *Windows of Christ Church*, 26–27, fig. 27.

26. Moses and other examples of ancestors in the twelve theological windows are documented and illustrated in Caviness, *Windows of Christ Church*, 9–10, 12–13, 16, 26–27, 30, 41, 52, 53, 84–85, 86, 91–92, 96, 103–4.

27. Caviness, *Early Stained Glass*, 25, 27.

28. For this window, see Caviness, *Windows of Christ Church*, 165–72, figs. 216–29.

29. Caviness, *Early Stained Glass*, 149.

30. Caviness, "Anchoress, Abbess and Queen: Donors and Patrons or Intercessors and Matrons?," in *The Cultural Patronage of Medieval Women*, ed. June Hall McCash (Athens: University of Georgia Press, 1996), 129–30.

31. See Caviness, *Windows of Christ Church*, 311–12, pl. 217.

32. Madeline H. Caviness, "A Lost Cycle of Canterbury Paintings of 1220," *Antiquaries Journal* 54 (1974): 60–74; Paul Binski, *Becket's Crown: Art and Imagination in Gothic England, 1170–1300* (New Haven, CT: Yale University Press for the Paul Mellon Centre for Studies in British Art, 2004), 3–12.

33. Caviness, *Windows of Christ Church*, 84.

34. Madeline H. Caviness, *Sumptuous Arts at the Royal Abbeys in Reims and Braine: Ornatus Elegantiae, Varietate Stupendes* (Princeton, NJ: Princeton University Press, 1990), figs. 115–20.

35. Secular genealogies were diagrammed from the eleventh century on, some as continuations of the line from Adam (Klapisch-Zuber, *L'ombre des ancêtres*, 105–43, 59–206, figs. 11–26).

36. The following information on the Canterbury Jewish community is given from documents examined by William Urry, *Canterbury under the Angevin Kings*, University of London Historical Studies (London: University of London, Athlone Press, 1967), 71, 119–20, 50–53. A broader account is that of Michael Adler, "The Jews of Canterbury," in *Jews of Medieval England* (London: E. Goldston for the Jewish Historical Society of England, 1939), 47–124. Cited by Urry, *Canterbury under the Angevin Kings*, 119, n. 1.

37. Caviness, *Early Stained Glass*, 115.

38. Thomas Walsingham and Matthew Paris, *Gesta abbatum monasterii Sancti Albani, a Thoma Walsingham, regnante Ricardo Secundo, ejusdem ecclesiæ præcentore, compilata*, Chronica monasterii S. Albani, ed. Henry ThomasRiley (London: Longmans, Green, 1867), 1:193–94.

39. Adler, "Jews of Canterbury," 62–63.

40. Adler, "Jews of Canterbury," 69, 83–102.

41. A full description of the program is in Caviness, *Reims and Braine*, 36–64, 142–47, pls. 1–8, 10, figs. 27–41, 45–79, 86–88, 246–70.

42. Caviness, *Windows of Christ Church*, 227–48, pls. 17, 163–78.

43. Measurements are derived from Karl Bernhard Kruse, "Zur Bautätigkeit Bischof Bernwards in Hildesheim," in *1000 Jahre St. Michael in Hildesheim: Kirche, Kloster, Stifter*, ed. Gerhard Lutz and Angela Weyer, Institut Hornemann and Hildesheim Internationale Tagung, Jahre St. Michael (Petersberg, Germany: Michael Imhof, 2012), pl. 23.

44. A detailed description is in Johannes Sommer, *Das Deckenbild der Michaeliskirche in Hildesheim* (Hildesheim, Germany: Gerstenberg, 1966), 51–56, 69–154. The ancestors are listed on pp. 132–33.

45. Harald Wolter–von dem Knesebeck, "Der Lettner und die Chorschranken sowie das Deckenbild von St. Michael in Hildesheim," in Lutz and Weyer, *1000 Jahre St. Michael*, 226–39, traces these developments and places cult objects in the context of the new decorations.

46. Sommer, *Deckenbild*, 15–19.

47. This is the direction invited by the ceiling, as restored in the nineteenth century. Earlier photographs show that the direction had been reversed in the Lutheran renovations (Sommer, *Deckinbild*, 9, pls. 4, 5).

48. Sommer, *Deckinbild*, 41–49, pls. 36, 38–41.

49. Caviness, *Reims and Braine*, 65–97, 145–47, 339–51, pls. 47–79, 190–203.

50. Madeline H. Caviness, "Tucks and Darts: Adjusting Patterns to Fit Figures," in *Medieval Fabrications: Dress, Textiles, Clothwork, and Other Cultural Imaginings*, ed. E. Jane Burns (New York: Palgrave Macmillan, 2004), 105–19, with a Web supplement at http://www.tufts.edu/~mcavines/glassdesign .html; figs. 9–13 show that Aminadab from Braine and Naasson at Canterbury are based on cartoons from Saint-Remi.

51. Dulce Ocón Alonso, "Las Pinturas de la Sala Capitular de Sigena," *Les Cahiers de Saint-Michel de Cuxa* 38 (2007): 81–94. It is interesting to note that all forty-two of Matthew's list could have been accommodated on three arches, but the proportion from each text is instead balanced.

52. Karl F. Schuler, "Seeking Institutional Identity in the Chapterhouse at Sigena," in *Shaping Sacred Space and Institutional Identity in Romanesque Mural Painting: Essays in Honour of Otto Demus*, ed. Thomas E. A. Dale and John Mitchell (London: Pindar, 2004). Inexplicably, he counts eighty-four ancestors, which would require a sixth arch. He also dates the foundation to 1188.

53. François Bucher, *The Pamplona Bibles: A Facsimile Compiled from Two Picture Bibles with Martyrologies Commissioned by King Sancho El Fuerte of Navarra (1194–1234)* (New Haven, CT: Yale University Press, 1970), 1:59–60; Eileen Patricia McKiernan González and Joan A. Holladay, "Monastery and Monarchy: The Foundation and Patronage of Santa María la Real de Las Huelgas and Santa María la Real de Sigena," http://repositories.lib.utexas.edu/bitstream /handle/2152/1630/mckiernangonzaleze52711.

54. Walter Oakeshott, *Sigena: Romanesque Paintings in Spain and the Winchester Bible Artists* (London: Harvey, Miller and Medcalf, 1972), 90–95, figs. 144–67; see also Caviness, *Early Stained Glass*, figs. 55–57.

55. Noble, "Genealogies of Christ," 202.

56. Hughes, *Manuscripts for Mass and Office*, 18–19, 259.

57. Schuler, "Chapterhouse at Sigena," 255.

58. Bucher, *Pamplona Bibles*, 207, fig. 49; the figures are named Isaac, Iacob, Iuda, Phares, Aram, Naasson, Salmon, Booz, Obed, Iesse.

59. Bucher, *Pamplona Bibles*, 23, 249–50.

60. Female ownership is adduced because of the greater number of female saints' lives in this book (ibid., 39, 262).

61. Los Angeles, UCLA, University Research Library, Special Collections, Arm. MS. 1; see Thomas F. Mathews and Avedis K. Sanjian, *Armenian Gospel Iconography: The Tradition of the Glajor Gospel*, Dumbarton Oaks Studies 29 (Washington, DC: Dumbarton Oaks Research Library and Collection, 1991), 86–89, figs. 28–35.

62. Baltimore, The Walters Art Museum, MS. W. 539: Sirarpie Der Nersessian, *Armenian Manuscripts in the Walters Art Gallery* (Baltimore: Trustees of the Walters Art Gallery Art, 1973), 10–30; fol. 218r has another twenty-four medallions, for Luke's genealogy (p. 14). See also Sirarpie Der Nersessian and Sylvia Agémian, *Miniature Painting in the Armenian Kingdom of Cilicia from the Twelfth to the Fourteenth Century*, Dumbarton Oaks Studies 31 (Washington, DC: Dumbarton Oaks Research Library and Collection, 1993), 1:61–62.

63. The names are listed by Der Nersessian, *Armenian Manuscripts in the Walters*, 12. Eight are omitted here: Matthew nos. 5. Phares; 9. Naasson; 12. Obed; 13. Jesse; 17. Abia; 18. Asa; 19. Josaphat; and 20. Jorim.

64. Constant Hamès, "La filiation généalogique (Nasab) dans la Société d'Ibn Khaldūn," *L'Homme* 27, no. 102 (1987): 99–118; Franz Rosenthal, *A History of Muslim Historiography*, 2nd rev. ed. (Leiden, Netherlands: Brill, 1968), 97–98; Rosenthal, "Nasab," in *Encyclopaedia of Islam* (Brill Online <http://referenceworks.brillonline.com/entries/encyclopaedia-of-islam-2/nasab-SIM_5807>, July 10, 2012).

Bibliography

Adler, Michael. "The Jews of Canterbury," 47–124. In *Jews of Medieval England*. London: E. Goldston for the Jewish Historical Society of England, 1939.

Alonso, Dulce Ocón. "Las Pinturas de la Sala Capitular de Sigena." *Les Cahiers de Saint-Michel de Cuxa* 38 (2007): 81–94.

Beatus of Liébana and Saint Jerome, *Comentarios al Apocalipsis y al Libro de Daniel: Edición facsímil del Códice de la Abadía de Saint-Sever Conservado en la Biblioteca nacional de Paris bajo la signatura Ms. Lat. 8878 / Commentaires sur l'Apocalypse et le Livre de Daniel: Édition en fac-similé du manuscrit de l'Abbaye de Saint-Sever conservé à la Bibliothèque nationale de Paris sous la cote Ms. Lat. 8878*. Serie Códices Artísticos 7. Madrid: Edilán, 1984.

Bede: The Reckoning of Time (725 CE). Translated by Faith Wallis. Translated Texts for Historians 29. Liverpool: Liverpool University Press, 1999.

Binski, Paul. *Becket's Crown: Art and Imagination in Gothic England, 1170–1300*. New Haven, CT: Yale University Press for the Paul Mellon Centre for Studies in British Art, 2004.

Blick, Sarah. "Reconstructing the Shrine of St Thomas Becket, Canterbury Cathedral," 1:405–41 (2:figs. 199–212). In *Art and Architecture of Late Medieval Pilgrimage in Northern Europe and the British Isles*, edited by Sarah Blick and Rita Tekippe. 2 vols. Leiden, Netherlands: Brill, 2005.

Bloch, R. Howard. *Etymologies and Genealogies: A Literary Anthropology of the French Middle Ages*. Chicago: University of Chicago Press, 1983.

Bucher, François. *The Pamplona Bibles: A Facsimile Compiled from Two Picture Bibles with Martyrologies Commissioned by King Sancho El Fuerte of Navarra (1194–1234)*. 2 vols. New Haven, CT: Yale University Press, 1970.

Caviness, Madeline H. "Anchoress, Abbess and Queen: Donors and Patrons or Intercessors and Matrons?" In *The Cultural Patronage of Medieval Women*, edited by June Hall McCash. Athens: University of Georgia Press, 1996.

——. *Art in the Medieval West and Its Audience*. Variorum Collected Studies 718. Aldershot, UK: Ashgate, 2001.

——. "Biblical Stories in Windows: Were They Bibles for the Poor?," 103–47. In *The Bible in the Middle Ages: Its Influence on Literature and Art*, edited by Bernard S. Levy. Binghamton, NY: Medieval and Renaissance Texts and Studies, 1992.

——. "Canterbury Cathedral Clerestory: The Glazing Programme in Relation to the Campaigns of Construction," 46–55. In *Medieval Art and Architecture at Canterbury before 1200*. British Archaeological Association: Conference Transactions for the Year 1979. London: British Archaeological Association and Kent Archaeological Society, 1982.

——. *The Early Stained Glass of Canterbury Cathedral, Circa 1175–1220*. Princeton, NJ: Princeton University Press, 1977.

——. "Images of Divine Order and the Third Mode of Seeing." *Gesta* 22 (1983): 99–120. Reprinted as chapter 2 in Caviness, *Art in the Medieval West*.

——. "A Lost Cycle of Canterbury Paintings of 1220." *Antiquaries Journal* 54 (1974): 66–74.

——. *Paintings on Glass: Studies in Romanesque and Gothic Monumental Art*. Variorum Collected Studies 573. Aldershot, UK: Ashgate, 1997.

——. "Romanesque 'belles verrières' in Canterbury?," 35–38. In *Romanesque and Gothic: Essays for George Zarnecki*, edited by Neil Stratford. Woodbridge, UK: Boydell Press, 1987. Reprinted as chapter 4 in Caviness, *Paintings on Glass*.

——. "'The Simple Perception of Matter' and the Representation of Narrative, Circa 1180–1280." *Gesta* 30 (1991): 48–64. Reprinted as chapter 3 in Caviness, *Art in the Medieval West*.

——. *Sumptuous Arts at the Royal Abbeys in Reims and Braine: Ornatus Elegantiae, Varietate Stupendes*. Princeton, NJ: Princeton University Press, 1990.

——. "Tucks and Darts: Adjusting Patterns to Fit Figures," 105–19. In *Medieval Fabrications: Dress, Textiles, Clothwork, and Other Cultural Imaginings*, edited by E. Jane Burns. New York: Palgrave Macmillan, 2004. Web supplement at http://www.tufts.edu/~mcavines/glassdesign.html.

——. "William of Sens and the Original Design of the Choir Termination of Canterbury Cathedral." *Journal of the Society of Architectural Historians* 42, no. 3 (October 1983): 238–48.

——. *The Windows of Christ Church Cathedral, Canterbury*. Corpus Vitrearum Medii Aevi, Great Britain 2. London: Oxford University Press for the British Academy, 1981.

Collinson, Patrick, Nigel Ramsay, and Margaret Sparks. *A History of Canterbury Cathedral*. Oxford: Oxford University Press, 1995.

Der Nersessian, Sirarpie. *Armenian Manuscripts in the Walters Art Gallery*. Baltimore: Trustees of the Walters Art Gallery, 1973.

Der Nersessian, Sirarpie, and Sylvia Agémian. *Miniature Painting in the Armenian Kingdom of Cilicia from the Twelfth to the Fourteenth Century*. 2 vols. Dumbarton Oaks Studies 31. Washington, DC: Dumbarton Oaks Research Library and Collection, 1993.

Doane, A. N., and William P. Stoneman. *Purloined Letters: The Twelfth-Century Reception of the Anglo-Saxon Illustrated Hexateuch (British Library, Cotton Claudius B. IV)*. Medieval and Renaissance Texts and Studies 395. Tempe: Arizona Center for Medieval and Renaissance Studies, 2011.

Dodwell, C. R. *The Pictorial Arts of the West 800–1200*. New Haven, CT: Yale University Press, 1993.

Draper, Peter. *The Formation of English Gothic: Architecture and Identity*. New Haven, CT: Yale University Press for the Paul Mellon Centre for Studies in British Art, 2006.

———. "William of Sens and the Original Design of the Choir Termination of Canterbury Cathedral." *Journal of the Society of Architectural Historians* 42, no. 3 (October 1983): 238–48.

Duggan, Anne J. "The Cult of St Thomas Becket in the Thirteenth Century," 21–44. In *St Thomas Cantilupe, Bishop of Hereford: Essays in His Honour*, edited by Meryl Jancey. Hereford, UK: Friends of Hereford Cathedral, 1982.

English Romanesque Art, 1066–1200. Exh. cat. London, Hayward Gallery, April 5–July 8, 1984. Edited by George Zarnecki, Janet Holt, and Tristram Holland. London: Weidenfeld and Nicolson in association with the Arts Council of Great Britain, 1984.

Gervase of Canterbury. "Tractatus de combustione et reparatione cantuariensis ecclesiae." In *Gervasii Cantuariensis opera historica*, edited by W. Stubbs. Vol. 1. Rolls Series 73. London, 1879.

Gibson, Margaret, T. A. Heslop, and Richard W. Pfaff, eds. *The Eadwine Psalter: Text, Image, and Monastic Culture in Twelfth-Century Canterbury*. Modern Humanities Research Association 14. London: Pennsylvania State University Press, 1992.

Gostling, William. *A Walk in and About the City of Canterbury with Many Observations Not To Be Found in Any Description Hitherto Published*. Canterbury, England, 1777.

Greenhill, Eleanor Simmons. *Die geistigen Voraussetzungen der Bilderreihe des Speculum Virginum: Versuch einer Deutung*. Beiträge zur Geschichte der Philosophie und Theologie des Mittelalters: Texte und Untersuchungen 39, no. 2. Münster, Germany: Aschendorff, 1962.

Hamès, Constant. "La filiation généalogique (Nasab) dans la Société d'Ibn Khaldūn." *L'Homme* 27, no. 102 (1987): 99–118.

Harris, Anne F. "Pilgrimage, Performance, and Stained Glass at Canterbury Cathedral," 1:243–81 (2:figs. 124–33). In *Art and Architecture of Late Medieval Pilgrimage in Northern Europe and the British Isles*, edited by Sarah Blick and Rita Tekippe. 2 vols. Leiden, Netherlands: Brill, 2005.

Harrison, Frank Ll. *Music in Medieval Britain*. 4th ed. Buren, Netherlands: Knuf, 1980.

Hearn, M. F. "Canterbury Cathedral and the Cult of Becket." *Art Bulletin* 76, no. 1 (March 1994): 19–52.

Heslop, T. A. "St Anselm, Church Reform, and the Politics of Art." *Anglo-Norman Studies* 33 (2011): 103–26.

Hughes, Andrew. *Medieval Manuscripts for Mass and Office: A Guide to Their Organization and Terminology*. Toronto: University of Toronto Press, 1995.

Janaro, John. "Saint Anselm and the Development of the Doctrine of the Immaculate Conception: Historical and Theological Perspectives." *Saint Anselm Journal* 3, no. 2 (Spring 2006): 48–56.

Kahn, Deborah. *Canterbury Cathedral and Its Romanesque Sculpture*. Austin: University of Texas Press, 1991.

Kauffmann, C. M. *Romanesque Manuscripts, 1066–1190*. Edited by J. J. G. Alexander, *A Survey of Manuscripts Illuminated in the British Isles*. London: Harvey Miller, 1975.

Kessler, Herbert L. "'Caput et Speculum Omnium Ecclesiarum': Old Saint Peter's and Church Decoration in Medieval Latium," 119–46. In *Italian Church Decoration of the Middle Ages and Early Renaissance: Functions, Forms, and Regional Traditions*, edited by William Tronzo. Ten contributions to a colloquium held at the Villa Spelman, Florence. Bologna: Nuova Alfa Editoriale, 1989.

Klapisch-Zuber, Christiane. "The Genesis of the Family Tree." *I Tatti Studies: Essays in the Renaissance* 4 (1991): 105–29.

———. *L'ombre des ancêtres: Essai sur l'Imaginaire médiéval de la Parenté*. Esprit de la Cité. Paris: Fayard, 2000.

Krautheimer, Richard. *Early Christian and Byzantine Architecture*. Harmondsworth, UK: Penguin, 1965.

Kruse, Karl Bernhard. "Zur Bautätigkeit Bischof Bernwards in Hildesheim." In Gerhard Lutz and Angela Weyer, eds., *1000 Jahre St. Michael in Hildesheim: Kirche, Kloster, Stitfer*. Institut Hornemann and Hildesheim Internationale Tagung, Jahre St. Michael. Petersberg, Germany: Michael Imhof, 2012.

Lutz, Gerhard, and Angela Weyer, eds. *1000 Jahre St. Michael in Hildesheim: Kirche, Kloster, Stifter*. Institut Hornemann and Hildesheim Internationale Tagung, Jahre St. Michael. Petersberg, Germany: Michael Imhof, 2012.

Marks, Richard. *Stained Glass in England during the Middle Ages*. London: Routledge, 1993.

Mathews, Thomas F., and Avedis K. Sanjian. *Armenian Gospel Iconography: The Tradition of the Glajor Gospel*. Dumbarton Oaks Studies 29. Washington, DC: Dumbarton Oaks Research Library and Collection, 1991.

Maynes, Mary Jo, et al., eds., Introduction, 1–23. *Gender, Kinship, Power: A Comparative and Interdisciplinary History*. New York: Routledge, 1996.

McKiernan González, Eileen Patricia, and Joan A. Holladay. "Monastery and Monarchy: The Foundation and Patronage of Santa María la Real de Las Huelgas and Santa María la Real de Sigena." PhD diss., University of Texas at Austin, 2005.

Michael, M. A. *Stained Glass of Canterbury Cathedral*. London: Scala, 2004.

Moore, Michael. "The King's New Clothes: Royal and Episcopal Regalia in the Frankish Empire," 95–135. In *Robes and Honor: The Medieval World of Investiture*, edited by Stewart Gordon. New York: Palgrave Macmillan, 2001.

Moore, Philip Samuel. *The Works of Peter of Poitiers, Master in Theology and Chancellor of Paris (1193–1205)*. Washington, DC: Catholic University of America, 1936.

Noble, Jeremy. "The Genealogies of Christ and Their Musical Settings," 197–208. In *Essays on Music and Culture in Honor of Herbert Kellman*, edited by Barbara Haggh. Collection "Epitome Musical" 8. Paris: Minerve, 2001.

Oakeshott, Walter. *Sigena: Romanesque Paintings in Spain and the Winchester Bible Artists*. London: Harvey, Miller and Medcalf, 1972.

Ohlgren, Thomas H., comp. and ed. *Anglo-Saxon Textual Illustration: Photographs of Sixteen Manuscripts with Descriptions and Index*. Kalamazoo: Medieval Institute Publications, Western Michigan University, 1992.

O'Reilly, Jennifer L. "The Double Martyrdom of Thomas Becket: Hagiography or History," 185–247. In *Studies in Medieval and Renaissance History*, n.s. 7, edited by J. A. S. Evans and R. W. Unger. New York: AMS Press, 1985.

Owen-Crocker, Gale R., Elizabeth Coatsworth, and Maria Hayward, eds. *Encyclopedia of Dress and Textiles in the British Isles c. 450–1450*. Leiden, Netherlands: Brill, 2012.

Pearson, Helen Bruch. *Mother Roots: The Female Ancestors of Jesus*. Nashville, TN: Upper Room Books, 2002.

Pfaff, Richard William. "Some Anglo-Saxon Sources for the 'Theological Windows' at Canterbury Cathedral." *Mediaevalia* 10 (1984): 49–62.

Rackham, Bernard. *The Stained Glass Windows of Canterbury Cathedral*. Canterbury, UK: S.P.C.K., 1957.

Rosenthal, Franz. *A History of Muslim Historiography*. 2nd rev. ed. Leiden, Netherlands: Brill, 1968.

———. "Nasab." In *Encyclopaedia of Islam*. Brill Online, http://referenceworks.brillonline.com/entries/encyclopaedia -of-islam-2/nasab-SIM_5807. Accessed July 10, 2012.

Rudolph, Conrad. "Inventing the Exegetical Stained-Glass Window: Suger, Hugh, and a New Elite Art." *Art Bulletin* 93, no. 4 (December 2011): 399–422.

Saint Ambrose. *Expositio Evangelii Secundum Lucam*. Centre Traditio Litterarum, Occidentalium 14. Turnhout, Belgium: Brepols, 2010. Accessed at http://hollisweb.harvard.edu /?itemid=|library/m/aleph|012933410.

Schaberg, Jane. *The Illegitimacy of Jesus: A Feminist Theological Interpretation of the Infancy Narratives*. Biblical Seminar 28. Sheffield, UK: Sheffield Academic Press, 1995.

Schuler, Karl F. "Seeking Institutional Identity in the Chapterhouse at Sigena," 245–56. In *Shaping Sacred Space and Institutional Identity in Romanesque Mural Painting: Essays in Honour of Otto Demus*, edited by Thomas E. A. Dale and John Mitchell. London: Pindar, 2004.

Scott, Margaret. *Medieval Dress and Fashion*. London: The British Library, 2007.

Smith, Lesley. *The Glossa Ordinaria: The Making of a Medieval Bible Commentary*. Commentaria 3. Leiden, Netherlands: Brill, 2009.

Snyder, Janet. "Cloth from the Promised Land: Appropriated Islamic Tiraz in Twelfth-Century French Sculpture," 147–64. In *Medieval Fabrications: Dress, Textiles, Clothwork, and Other Cultural Imaginings*, edited by E. Jane Burns. New York: Palgrave Macmillan, 2004.

———. "The Regal Significance of the Dalmatic: The Robes of *Le Sacre* as Represented in Sculpture of Northern Mid-Twelfth-Century France," 291–304. In *Robes and Honor: The Medieval World of Investiture*, edited by Stewart Gordon. New York: Palgrave Macmillan, 2001.

Sommer, Johannes. *Das Deckenbild der Michaeliskirche in Hildesheim*. Hildesheim, Germany: Gerstenberg, 1966.

The St. Albans Psalter Project (2003), King's College, University of Aberdeen, Scotland, www.abdn.ac.uk/stalbanspsalter /english/index.

Throckmorton, B. H., Jr. "Genealogy (Christ)," 365–66. In *The Interpreter's Dictionary of the Bible: An Illustrated Encyclopedia Identifying and Explaining All Proper Names and Significant Terms and Subjects in the Holy Scriptures, Including the Apocrypha, with Attention to Archaeological Discoveries and Researches into the Life and Faith of Ancient Times*, edited by George Arthur Buttrick. New York: Abingdon Press, 1962.

Ulanov, Ann Belford. *The Female Ancestors of Christ*. Boston: Shambhala, 1993.

Urry, William. *Canterbury under the Angevin Kings*. University of London Historical Studies. London: University of London, Athlone Press, 1967.

Vaughan, Richard, ed. and trans. *Chronicles of Matthew Paris: Monastic Life in the Thirteenth Century*. Gloucester, UK: Alan Sutton and St. Martin's Press, 1984.

Walsingham, Thomas, and Matthew Paris. *Gesta abbatum monasterii Sancti Albani, a Thoma Walsingham, regnante Ricardo Secundo, ejusdem ecclesiæ præcentore, compilata*. 3 vols. Chronica monasterii S. Albani, edited by Henry Thomas Riley. London: Longmans, Green, 1867–69.

William of Malmesbury. *De gestis pontificum anglorum*, edited by N. Hamilton. Rolls Series 52. London: Longman, 1870.

Willis, R. *The Architectural History of Canterbury Cathedral*. London: Longman, 1845.

Wolter–von dem Knesebeck, Harald. "Der Lettner und die Chorschranken sowie das Deckenbild von St. Michael in Hildesheim," 226–41. In *1000 Jahre St. Michael in Hildesheim: Kirche, Kloster, Stifter*, edited by Gerhard Lutz and Angela Weyer. Institut Hornemann and Hildesheim Internationale Tagung, Jahre St. Michael. Petersberg, Germany: Michael Imhof, 2012.

Woodman, Francis. *The Architectural History of Canterbury Cathedral*. London: Routledge and Kegan Paul, 1981.

Zaluska, Yolanta. "Le Beatus de Saint-Sever à travers sa composition matérielle et ses généalogies bibliques," 279–92. In *Saint-Sever, Millénaire de l'Abbaye: Colloque international, 25, 26 et 27 Mai 1985*, edited by Jean Cabanot. Mont-de-Marsan, France: Comité d'études sur l'histoire et l'art de la Gascogne, 1986.

Acknowledgments

I first saw panels from the Ancestors of Christ windows at Canterbury on a brilliant December day in 2009. A few of the figures had been placed on light tables in the glass studio where I was introduced to them by Léonie Seliger, Director of Stained Glass at Canterbury, and Brigadier John Meardon, the Receiver General. I was immediately struck by the extraordinary presence of figures such as *Methuselah* and *Noah*. To be literally face to face with these great monuments of early medieval stained glass has been a tremendous experience that all of us who have worked together on this project are honored to share with a wide audience through this publication and the accompanying exhibition, *Canterbury and St. Albans: Treasures from Church and Cloister*. I am deeply grateful to John and Léonie for their generous and enthusiastic collaboration in making this possible.

I thank everyone in the cathedral's Stained Glass Studio: Laura Atkinson, Grace Ayson, Joy Bunclark, Alison Eaton, David Griffiths, Bettina Koppermann, Daniel Steinbach, and Buffy Tucker for their work and assistance in providing access to the panels, preparing them for exhibition, and sharing their great knowledge and love of the glass. I also thank Andrew Edwards at the Canterbury Cathedral Trust for his supportive contributions to this project, and to Robert Greshoff for his beautiful photography of many of the ancestors panels and the cathedral interiors.

I am grateful to Madeline Caviness for her support of the exhibition and for generously sharing her scholarship and advice with me in the preparation of this text and for contributing her stimulating essay to the book. She and I both acknowledge those in Getty Publications who contributed to this handsome volume: Kara Kirk, publisher; Rob Flynn, editor in chief; Elizabeth Nicholson and Dinah Berland, editors; Elizabeth Kahn, production coordinator; Kurt Hauser, designer; Pam Moffat, photo researcher; and editorial consultants Jane McAllister, manuscript editor, and Karen Stough, proofreader.

I wish to acknowledge all of those at the J. Paul Getty Museum who contributed their skills and expertise to the exhibition on which this book is based, I am particularly thankful for the collaboration of Kristen Collins, associate curator of manuscripts and the co-curator of the exhibition, which received critical support and encouragement from Thomas Kren, associate director for collections; Quincy Houghton, associate director for exhibitions; Antonia Boström, then senior curator of sculpture and decorative arts at the Getty Museum; and Elizabeth Morrison, senior curator of manuscripts. Both the exhibition and publication benefited over time from the leadership and support of Getty Museum directors Michael Brand, David Bomford, James Cuno, and Timothy Potts.

The exhibition was designed by Robert Checchi and Donna Pungprechawat and would not have been possible without the work of the many colleagues at the Getty with whom we were privileged to work: Tuyet Bach, Jane Bassett, Cherie Chen, Brian Considine, John Giurini, Rita Gomez, Leigh Grissom, Stephen Heer, Sally Hibbard, Chris Keledjian, Kevin Marshall, Susan McGinty, Michael Mitchell, Mark Mitton, Adrienne Pamp, Kanoko Sasao, Toby Tannenbaum, and Nancy Turner. I also wish to thank Peter Barnet and Timothy Husband at the Metropolitan Museum of Art in New York for their support and collaboration with the exhibit and for providing a further venue for the glass at the Cloisters.

Finally, I want to acknowledge my colleagues in the Getty's Department of Sculpture and Decorative Arts: Charissa Bremer-David, Anne-Lise Desmas, and Ellen South, along with former department interns Maggie Crosland and Elizabeth Osenbaugh, and outside colleagues and friends Melissa Knatchbull, Ann Lucke, Adrian Sassoon, Margaret Scott, and Kyle Wilson. I thank them all for their assistance and encouragement with this project. It has been an honor to work with so many in bringing together the exhibition and presenting this publication that both raise the profile of these extraordinary windows and contribute to the joy of sharing great works of art with others.

Jeffrey Weaver

Index

This publication is issued in conjunction with the exhibition *Canterbury and St. Albans: Treasures from Church and Cloister*, on view at the J. Paul Getty Museum at the Getty Center, Los Angeles, from September 20, 2013, to February 2, 2014, and a display of the Ancestors of Christ windows organized by the Metropolitan Museum of Art, New York, at the Cloisters, from February 25 to May 18, 2014.

Published by the J. Paul Getty Museum, Los Angeles
Getty Publications
1200 Getty Center Drive, Suite 500
Los Angeles, California 90049-1682
www.getty.edu/publications

Elizabeth S. G. Nicholson and Dinah Berland, *Editors*
Kurt Hauser, *Designer*
Elizabeth Chapin Kahn, *Production Coordinator*

Printed in Hong Kong

Library of Congress Cataloging-in-Publication Data
Weaver, Jeffrey, author.
 The Ancestors of Christ windows at Canterbury Cathedral / Jeffrey Weaver, Madeline H. Caviness.
 pages cm
 "This publication is issued in conjunction with the exhibition Canterbury and St. Albans: Treasures from Church and Cloister, on view at the J. Paul Getty Museum at the Getty Center, Los Angeles, from September 20, 2013, to February 2, 2014."—ECIP galley
 Summary: "Discusses the original context, iconographic program, and stylistic development of the Ancestors of Christ windows, which survive from the twelfth century and are significant examples of English medieval painting and monumental stained glass"—Provided by publisher.
 Includes bibliographical references and index.
 ISBN 978-1-60606-146-6 (pbk.)
 1. Glass painting and staining, Medieval—England—Canterbury. 2. Stained glass windows—England—Canterbury. 3. Canterbury Cathedral. 4. Anglican church buildings—England—Canterbury. I. Caviness, Madeline Harrison, 1938- author. II. J. Paul Getty Museum. III. Title. IV. Title: Canterbury and St. Albans, treasures from church and cloister.
 NK5308.W39 2013
 748.509422'34—dc23
 2013008309

FRONT COVER: *Jared*, from the Ancestors of Christ Windows, Canterbury Cathedral. Attributed to the Methuselah Master, 1178–80 (detail, fig. 28)
BACK COVER: *Noah*, from the Ancestors of Christ Windows, Canterbury Cathedral. Attributed to the Methuselah Master, 1178–80 (see fig. 35)
HALF-TITLE PAGE: Detail from the border that originally framed *Methuselah* and *Lamech* (detail, fig. 33).
FRONTISPIECE and FRONT COVER FLAP: Light from Stained Glass Windows on Stone at Canterbury Cathedral, 2013
PAGES 4–5: *Adam*, from the Ancestors of Christ Windows, Canterbury Cathedral. Attributed to the Methuselah Master, 1178–80 (detail, fig. 12)